skate & art

MICHELE ADDELIO

ARTISTS INSPIRED BY SKATEBOARDING

Lannoo

preface — Michael Sieben

Art, like skateboarding, is inherently subjective, but with historical context we can easily differentiate between originality and copycatting.

And when something is unique, when it screams authenticity, when it's undeniably pure, that's where the magic lies. And all of us possess this stardust — you just have to ask yourself: Are you speaking your truth? Are you following your own compass? Are you allowing your intrinsic style to bleed out onto the canvas? If the answer is always no, then you're probably just doing cover songs. Which is fine. And fun. But maybe not art.

You don't have to be a virtuoso to make a great painting. Likewise, you don't have to be a phenomenal athlete to be a good skateboarder.

What you do need, however, is to find your own inherent sense of style.

All of the visual artists featured in this compendium have dug deep and unearthed their own methodology, depicting skate style filtered through their distinctive artistic lens. And, although we've already established that it's completely subjective, I'll go on record and say they're all fantastic artists in their own right. Now, I'm gonna need to see some skate footy to determine whether or not they're good skateboarders. Not you, Henry Jones. I've seen you skate. You're in the clear.

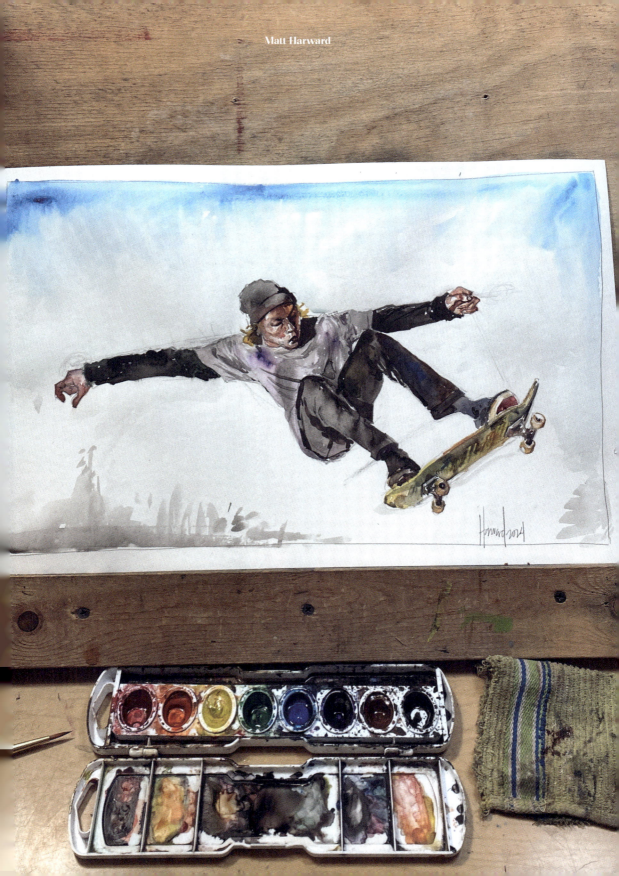

Matt Harward

008 intro

Allison Scarry[010]
Aron Leah[020]
Bruno Laurent[030]
Christian Stearry[040]
Doeke de Walle[052]
Duncan Kirkbride[062]
Erik Ziegler[072]
Hannah Forward[082]
Henry Jones[092]
Hiroki Muraoka[104]
Jack Hyde[116]
Jimbo Phillips[128]

Jonatan Hiroki Bando[138]
Kasiq Jungwoo[150]
Lorna Goldfinch[160]
Lucas Beaufort[170]
Matt Harward[180]
Max Schotanus[190]
Natalia Ablekova[200]
Pat De Vera Sison[210]
Pedro Colmenares Carrero[222]
Trevor Humphres[232]
Tuck Wai[244]

intro — Michele Addelio

Skateboarding is not a crime.

This was a famous slogan when I started skating in the mid-80s. Not just brilliant marketing, it was how we skaters really felt and how we were seen in the eye of the public. To us, however, skateboarding is a way of life, expressing our creativity and freedom to develop our identity no matter what everybody else thinks, sometimes spurring our rebellious side to further manifest our lifestyle. Who would have thought that — many years later — skateboarding would hit the mainstream all the way up to luxury brands? Not to mention the Olympics. Sometimes I wish skateboarding were seen as a crime again.

My name is Michele Addelio, founder and editor of *Backside*, a small but global skateboard magazine uncovering the skate scene beyond the mainstream. One of the mag's key features, ARTboard, is where I have been interviewing and showcasing artwork for more than 50 skateboard-inspired artists. Whilst I appreciate a great board graphic or deck used as a canvas, I am more fascinated by artwork that exhibits skateboarding and the artist behind it all. In fact, the cover of my very first *Backside* issue in 1996 was a skateboard illustration.

Skateboarding prides itself, just like art, on having no boundaries. Hence the aim of *Skate & Art* is to give you a glimpse of what the hugely diverse skateboard culture has to offer. Providing different perspectives through established artists that work in the skateboard industry, to upcoming illustrators that are part of the skateboard community, all the way to hidden gems that sit outside the community but are influenced by it. From illustrations inspired by iconic skate photographs to secret skate spots in the woods. From paintings capturing various cultural backgrounds to skate cartoons and comics. From oil paintings to digital art. From black and white to bright colours. There are no limitations. Just like skateboarding. And art.

Welcome to *Skate & Art*.

All my royalties from the sale of this book will be donated to Make Life Skate Life, a non-profit organisation that builds skateparks for underprivileged youth around the world.

Time to give back. Thank you, skateboarding. For everything.

01

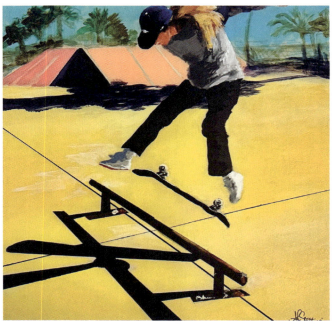

Electricity in the Air

Vibrant women

Allison Scarry

From working in a skate shop to becoming a kindergarten teacher and being a skater and artist in between, Allison creates traditional oil and acrylic paintings. She nails the level of details in her paintings while embracing the challenges of colour consistency and dry time.

allisonscarry.com ~~~~ @scarryart

'Not to mention
the huge impact
of art on
the skate world
in general,
it is a very
natural
connection
for me.'

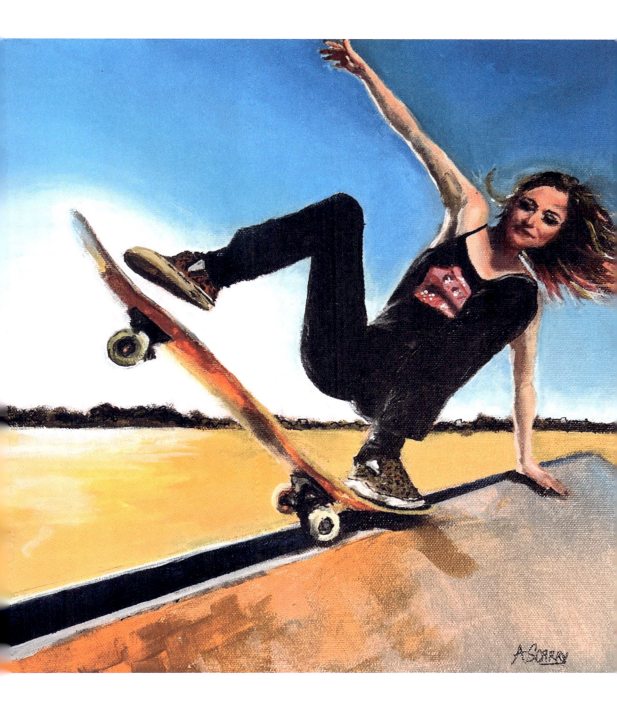

Skateboard Sam'ba

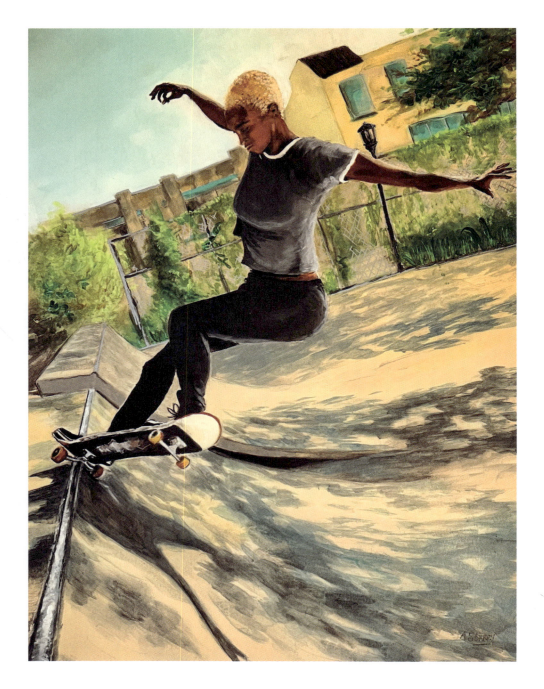

'This painting is of a wonderful human being and skater Mame, based on a photo shared with me by Tracy Mammolito.'

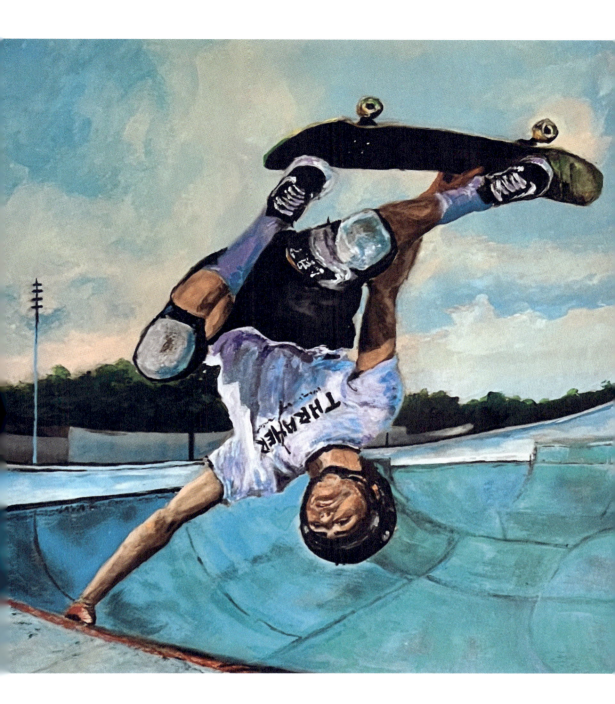

Hold The Bowl

Q & A
Allison Scarry

Virginia Beach, US

What inspired you to draw skateboard sketches?
I actually love to skate and have always loved skate culture. I started working in a skate shop at 17 years old and learned all the ins and outs of putting together skateboards and also had access to tons of skate magazines, books and videos. One book in particular was on the history of skateboard art. As a female, there was an obvious lack of women and girls involved in the culture as a whole. There were some but it was a definite minority, and I just remember thinking why the heck aren't there more. I can't tell you how many times people would come in to get a skateboard put together or grip tape etc. applied to a new deck, and they would assume I couldn't help them just because I was a woman. So when I came back to art a few years ago, it just felt natural to depict skating, and maybe subconsciously it was me 'showing them', whoever they are *(laughs)*. I do love to highlight women skaters, though. I have also been able to depict some really great men skaters too.

How has skateboarding influenced your work as an artist?
It has definitely shown up in the subjects and in capturing the insane beauty and skill of skateboarding. Not to mention the huge impact of art on the skate world in general, it is a very natural connection for me.

How did you get into drawing?
From as early as I can remember, I actually used to get in trouble for drawing all over things I shouldn't, like myself, the walls, even a friend's entire garage floor with a Sharpie. I was about five so I promise it was not intentional damage *(laughs)*.

What has been your proudest moment?
This is tough. I think there have been a lot of proud moments, but you quickly go 'okay, what is the next goal?' Everything from seeing my work in galleries and in print to seeing it resonate with others or hearing how much someone loves a piece and why, and of course being able to highlight or support others through that as well.

You mainly paint with oil and acrylic. What are the main challenges with these techniques?
Acrylic is tricky for some people because it dries fast, so you have to have the right colour and know how and where you want to apply it. If you thin it out with water, you can get almost a watercolour-like consistency. Oil is slow drying and there is so much that I still don't know about it, but I continue to learn. It's definitely difficult finding products that aren't too toxic, whether they're for thinning the paint or cleaning brushes, or even products you can add to help it dry faster.

Are there any skateboard-inspired artists you follow?
Butch Hartman — he does some insane coloured pencil graphics on decks before he pours resin on them! They're amazing! Also Marc Emond, a skater and skate artist, and Mike Manis (a skate photographer). His work really focuses on skate, and it captures that early skate-era art style you might see on decks and in magazines but with a modern touch.

Which board company do you like most in terms of their graphics?
Oh, this is hard. I mean, I have to say Santa Cruz and Powell Peralta, especially when they have retro-inspired graphics. *There Skateboards* has some I like too. This is one of those things where sometimes a lot of them look similar. When I'm in a skate shop and just staring at the wall of choices, I always notice the ones that stand out from the rest.

What do you do when you're not painting?
I'm a kindergarten teacher, so during the school year, this keeps me busy. I skate and love being outside and spending a lot of time exploring. Playing, trying new things. Anything that lets you observe and be present and use your senses is such a gift.

Have you thought about becoming a full-time freelancer instead?
Absolutely, that would be the dream. Being able to fully rely on it as an income and to focus on it full time would be incredible. I would still have to do something to give back to kids and stir up their potential, but I'm sure I would find ways to do that outside the classroom.

What else is on your wish list?
Definitely travel to Europe, and spending at least a month, living and exploring and meeting some of the amazing artists and skaters I have had the privilege of connecting with over the years.

Last question. If you could interview any person in the world, who would it be?
Yikes, this is hard. It's kind of like the three wishes question, where you have to use it wisely. If I had any chance of asking the right questions to provoke someone in a position of power to influence things for the better, then I think I would need to use this on some of the most influential people. At the end of the day, maybe the biggest billionaires in the world — there is so much good and so much change these people could initiate for the better and for future generations, and you just wonder, do they just not care or do they not know where to start? •

02

The grind

The bare minimum

Aron Leah

Aron had a lot of random jobs until one day, in Morocco, his wife convinced him to start drawing again. He is now a full-time freelancer who has also transitioned from overdoing his drawings to using the bare minimum to convey his message.

'Bryan Herman is one of my favourite skaters. Homage to him ollieing over a school bench. I'm imagining my creative process like a line in a video, this is midway through and getting to the banger. Hopefully.'

Pencil tricks

'I've always felt that, aesthetically, skateboarding is kind of beautiful to watch.'

Q & A

Aron Leah

Bournemouth, UK

How did you get into drawing?
Well, I guess – like all kids – I started drawing at a really young age. I remember it always being a chance for me to escape and have fun. My bedroom walls were literally covered in drawings.
I stopped drawing for a long time and it wasn't until I was around 25, when my now wife and I were in Morocco, that I started drawing again. She told me I should keep doing it, so I did *(laughs)*. I think I needed something to put my energy into and one thing led to another and now I draw every day.

What is your medium of choice?
Pencil and paper. I also use my iPad and then Adobe Illustrator for commercial projects. The iPad lets you erase and edit stuff really easily. With sketchbooks, I purposely don't buy erasers so that when I draw, I can't change it. It keeps it interesting because if I do make a mistake, I have to roll with it.

How would you define your style?
Minimal single line. I like line weights to be the same as it allows me to draw details whilst retaining a level of simplicity. Using a pencil gives a more organic feel to the lines. Then, in terms of my thinking, I try to use a mix of surrealism, abstract and more literal ways of visual communication. Storytelling.

In an interview, you mentioned that you ruined your drawings when you were younger by overdoing them. Now they look very simple, basic, yet they still convey a message. How did you get from one extreme to the other?
(Laughs). Yeah, I used to get told 'if you add more you'll ruin it'. I'd always add more. Whilst I was working as a graphic artist for a clothing brand, I got really into logo and brand design. A logo needs to communicate something at a really simple and basic level. Most logo designers use grid paper, so I started doing the same. At first, it felt really uncomfortable trying to fit complex ideas or parts of a brand into this small icon that needed to work visually on both a large and small scale. Eventually, it became easier, and I enjoyed the challenge of it. I think that's where my love for storytelling through illustration began. The way I created a logo became the way I created an illustration. Trying to say as much as possible with as little as possible. I think what logos and design taught me from a commercial sense is that the work needs to function for a brand in different locations, online, in-store, etc. I try to have that intention with illustration too. I also felt like it needed to grab attention and spark conversation. I found illustration to be a great way to do that. It's where my version of logo design and illustration met and became what I create for people. Over time, illustration just took over because I love drawing and want to spend

more time doing it. My intention of simple visual storytelling has remained, though.

What is your connection with skateboarding?

Although I have never considered myself a skater, it's always played a big part of my life as I pretty much grew up at skateparks riding BMX and have always hung out with skaters. I've always felt that, aesthetically, skateboarding is kind of beautiful to watch. It's stylish and progressive, which I find really appealing. From an illustration perspective, sometimes it's the form I enjoy drawing. Like someone doing a heelflip or a massive ollie – it just looks cool and is fun to draw. Other times, I use a skateboard as a tool when communicating an idea. This is how I add my influences to what I create, even on commercial projects. These days, skateboarding is way more accessible, and people can relate to it.

How has your exposure to skateboarding influenced your work as an artist?

The culture, people and specifically the artists within skating have 100% influenced me. Ed Templeton, Michael Sieben, Todd Francis, BB Bastidas, to name a few. I've always admired their creativity and their approach to being an artist. I try to catch interviews with them in magazines or online. I'll watch them again from time to time to remind myself to keep pushing. Anyone who is unapologetically themselves, I find really motivating. It's hard to make a career out of your artwork. You have to deal with a lot, and then sometimes that doesn't always go away. I've always likened it to when you've been trying to land a trick for ages and keep stacking, but you keep getting up and trying again until you get it. That takes a certain amount of grit and determination, and I feel like sometimes you need that to be a commercial artist.

You've had all sorts of random jobs. When did you decide to go all in as a full-time artist?

I mentioned drawing in Morocco. That led to starting a small clothing brand, which led to an interview for a much bigger clothing brand where I ended up being a graphic artist. I couldn't even use the software and had little to no experience. My whole life, I've struggled to work for people, but I knew this was a huge opportunity, so I just soaked up as much as possible and used every second to learn and get better. Eventually, I reached my limit. I was freelancing on the side anyway, so I just took that step and went full-time. We had two young kids, so it was really scary, but I don't regret it for a second.

Last question. If you could interview any person in the world, who would it be?

Probably Jon Contino. He's an illustrator from New York and I just respect how he's gone about making a living in the creative industry. I wouldn't even need to interview him. I'd be happy just shooting the breeze over coffee. •

03

Giraud

The lead up

Bruno Laurent

Less is more for Bruno, who is a background designer for children's cartoons by trade. His artworks are simple, sometimes only illustrating the skater's approach to an obstacle and getting ready for the trick. However, they still grab and hold the viewer's attention, leaving you to imagine what might happen next.

behance.net/bubix ~~~ @bubix

'There has always been a very close link between drawing and the board culture for me.'

< 'I tried to draw the movement
 of a grind in a bowl.
 The skater is fictitious.'

Q & A

Bruno Laurent

Nantes, France

Your job title is background designer. What does this involve exactly?
I've been working as a background designer and concept artist in the cartoon sector for over 10 years, on projects for various animation companies. I generally create backgrounds in 2D cartoons. Sometimes I do character design research too. And I'm also a teacher for private animation schools. I mainly work for children's cartoons like Nate Is Late, Nawak, The Crunchers, Moka, Taffy, Trulli Tales, Boy Girl Etc. and F Is For Family. Right now, I'm developing two TV shows for children and adolescents for French animation companies.

How did you get into drawing?
When I was at nursery school, a teacher told me that I doodled quite well for my age. I think I didn't overdo my colouring. And since then, I've never stopped.

How would you describe your style?
When I work for the cartoon sector, my style is quite variable, but when I draw for myself, I like to play with shapes and lines. My style is primarily angular.

What is your medium of choice?
A pencil and graphics tablet.

You include skateboarding in some of your illustrations. Is there a special connection?
I started skateboarding in my town at the age of eight and entered a few competitions that went pretty well. Unfortunately the skatepark closed, and I got more into drawing, but I've always loved skating and other board sports such as snowboarding, kitesurfing and surfing. There has always been a very close link between drawing and the board culture for me.

What about skateboarding inspires you?
When I first started to skate it was all about freedom. In the 90s in France it was fashionable to skate, and I let myself be fooled by that. Later, I rediscovered and appreciated the spirit of perseverance that skateboarding brings with it. It can take you up to a year to learn one trick. I like the simplicity of skateboarding: a wooden board with wheels, and the city becoming a playground.

Does being an artist influence how you skate or feel about it?
I don't know if it influenced me, but I always wanted to keep this feeling of freedom, whether in my graphic or professional drawings. So far, I've managed to go where I wanted without disguising myself artistically or professionally. I really like the mentality of Jay Adams in the film *Lords of Dogtown* – a must-see film not just for skaters.

What has been your proudest moment?
When I landed on my first Airwalk in the park. The feeling of landing it was incredible.

Have you had any embarrassing or funny moments along the way?
My first real skate competition in Paris, where I eventually realised that I didn't have the skills to compete at that level.

Have you ever thought of becoming a full-time freelancer?
There is a special kind of unemployment insurance scheme for artists in France. This system removes the pressure for artists as they continue to pursue their career.

If you could choose to be a pro skater or a full-time artist, which would it be?
At the moment, I'm happy with my situation. I can practise skateboarding in my city and draw full time for work. It's everything I dreamed of when I was younger.

Are there any skateboard-inspired artists that you follow?
I love the work of Frederic Forest, Ludovilk Myers and also Lucas Beaufort, who I used to work with. I also admire the work of Jim Phillips and so many others. I've never worked with these artists – I just love their work.

Which board company grabs your attention in terms of their graphics?
Back in the day, I would have immediately said World Industries or Blind. Today, I would say the Toy Machine or Creature. The *Ripndip* brand is fun too.

What does your dream assignment look like in terms of brand and scope?
I would love to design a skateboard graphic for a board company.

Last question. If you could interview any person in the world, who would it be?
One of the first men, to find out why he drew in caves. •

01
02
03
04
05
06
07
08
09
10

Aaron Jones

Curbtoons

Christian Stearry

041

Christian found his artistic destiny by drawing what he knew and that was skateboarding. His style is very refreshing as he uses traditional media like acrylic paint on paper to illustrate cartoon-influenced artwork. Apparently, his artistic expression is very similar to the way he skates.

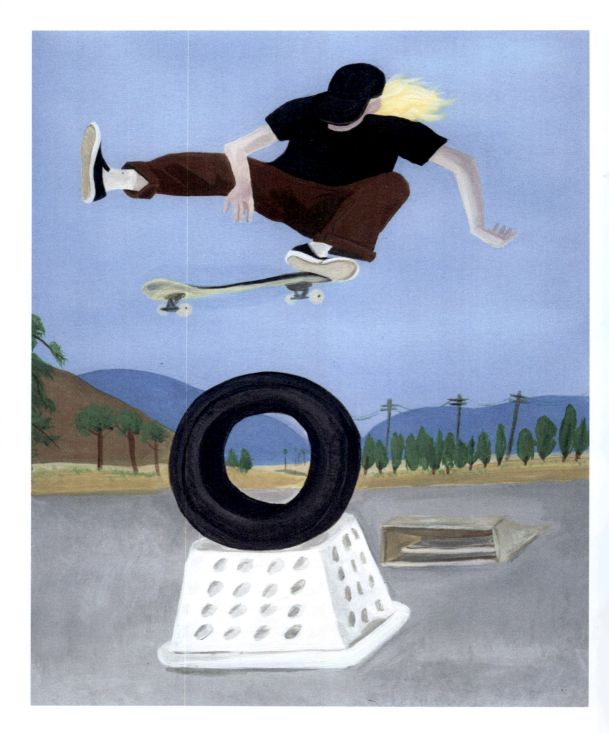

'The tire drawing was from a photo in the *Thrasher* photograffiti section, which are reader submitted images.'

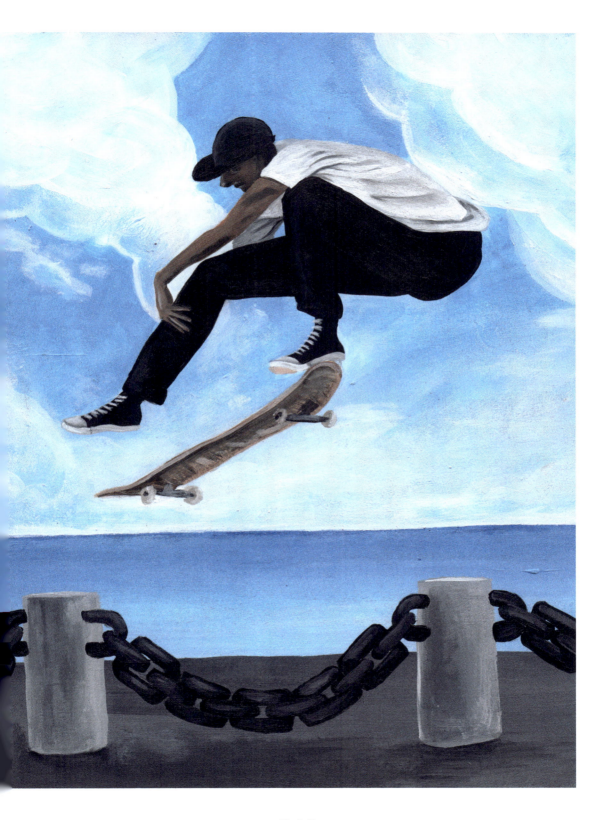

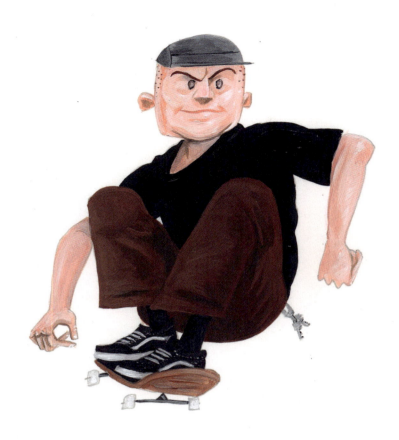

Hydrant Ollie

046

'I've definitely always enjoyed weirder or creative approaches to skating.'

'The hydrant Ollie was just a sketchbook doodle, the hydrant is just an iconic basic skate obstacle I like to draw.'

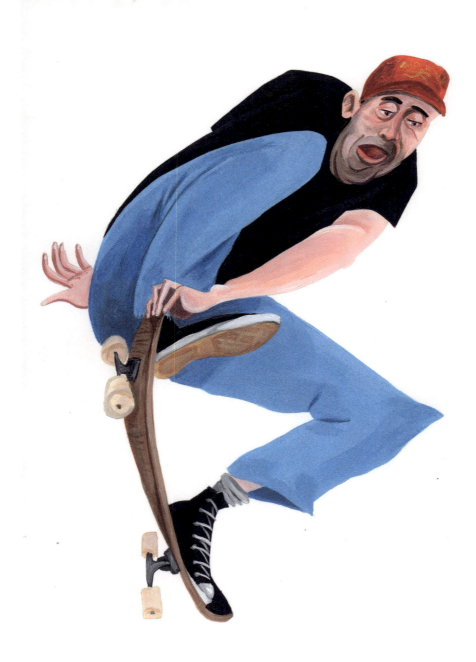

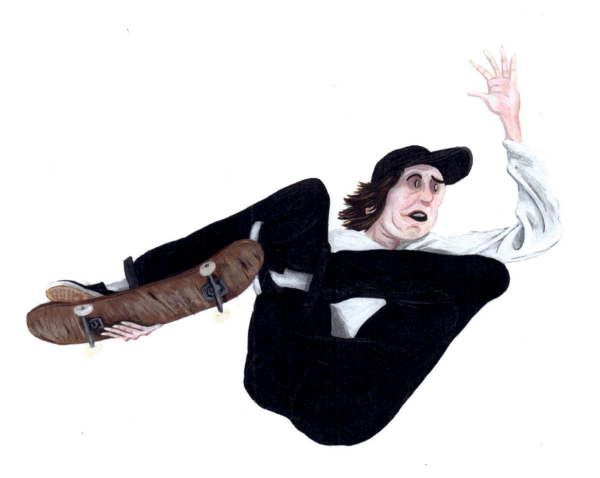

Stalefish

Q & A

Christian Stearry

Toronto, Canada

What came first: drawing or skateboarding?
Drawing. I always loved drawing. Skating was something I didn't get into until I was a teenager, although it was always in the back of my head from video games and TV. My dad skated when he was younger too.

What is your medium of choice?
Most of the work I post online is acrylic paint on paper, but I draw a lot in my sketchbook with pencil and pencil crayons, and sometimes with markers too.

How did you get into drawing?
I used to make paper doll versions of the wrestling action figures my mom wouldn't buy for me. And I loved drawing in school when I got bored of the pace of a class. I was pretty good at English and history so I could breeze through those classes and draw. It definitely hurt my math skills though (laughs). Drawing is a great way to engage with your favourite cartoon or other interests. It's also a great way to get around the rules a bit.

You started skating as a teenager. What triggered this?
The big thing that got me into it was moving to a small town. There were some kids on my street who skated. My little brother started hanging with them first. At one point he and another kid were sharing one board and then over time we all got into it, and all got boards. We were like a little crew. I wound up becoming the most invested in it, though, and started skating with other kids in the town who were closer to my age.

How has skateboarding influenced your work as an artist?
I suppose board graphics were a starting point, but I think the magazines were really what did it for me. Transworld used to have a 'Letters to the editor' section, and they'd always have a guest illustrate that month's crazy stories. Product ads and tour articles definitely piqued my interest in illustration and design. Also, for a long time I didn't really know what subject matter I wanted to approach. Pop Surrealism and weirdness were popular at the time. I liked that stuff, but I was never that good at creating it. One day I just started 'drawing what I knew' and what I knew was skateboarding.

Has your work on illustrations also shaped how you skate or how you feel about it?
I once had a guy who knew my work and knew that I lived nearby. He guessed who I was based on the way I skated at my local park. I had hurt my ankle at the time and was skating silly in a goofy outfit and with a cruiser board so maybe that was why (laughs). I've definitely always enjoyed weirder or creative approaches to skating. Jason Adams and Louie Barletta,

as well as Chris Haslam and Daewon Song, really informed my approach to skateboarding. I think that ties in with the sort of cartoony way I depict skateboarding. It's sort of a self-feeding cycle.

Ever thought about turning your illustrations into a permanent gig?
I did a big art show with some pals that went really well, and then enrolled in design school. I was working towards that but the pandemic complicated things. However, I just got my diploma in graphic design at George Brown College in Toronto in spring 2024 and I'm currently trying to get the ball rolling with some projects later this summer! In the meantime, I've been painting houses all over Toronto for designers and real estate agents. I may transition into working on film sets in the future, but it all depends on where the road takes me.

CURBTOONS - The Art of Cartooning and Skateboards is a book you published as part of your design thesis uncovering the skate cartoonist. Is there anything that you did not expect or learned from it?
CURBTOONS, yes! That was a really fun project. Again, it was a situation where, once I created work that was 'about what I knew', it came out very naturally. I learned a few things! One: People are pretty eager and excited to talk about what they love and are often grateful for the opportunity to do so. Two: It turns out I'm part of a network that was able to help me get hold of a few artists who were otherwise difficult to reach. That was really cool. Three: I was way more captivated by the process of writing interviews than I was by designing the book itself. That was an interesting insight about myself.

Are there any differences between the skate cartoonist and general skateboard illustrators?
Honestly, I don't think so. Skateboarders are generally pretty nerdy, and a lot of them are into some kind of creative outlet. A lot of the guys I talked to were also very skilled skateboarders as well. I think both endeavours come from a similar headspace.

Are there any other skateboard-inspired artists who influence your work?
Oh, definitely. Ed Templeton, Mike Sieben, Margaret Kilgallen and Andrew Pommier were definitely early influences. Mike Giant, Barry McGee and Steve Powers are some graffiti scene influences who were skate-adjacent. You know, *Juxtapoz Magazine*-type stuff. Everyone in my book inspires me in a peer-to-peer kind of way too. I'm also into comics and cartoons, like Ren and Stimpy, Robert Crumb, Charles Burns and Daniel Clowes, as well as more traditional art world characters like Alex Katz, Alex Colville, Édouard Manet and Paul Gauguin, among many, many others.

Last question. If you could interview any person in the world, who would it be?
I'd maybe interview Alex Katz. He might seem a little dry, and he's 97 years old, but I think he'd have an interesting perspective on contemporary figurative artwork and just the modern world in general. I've liked his work for some time now, and I think he's become a little more popular in recent years. I'd be curious to know his feelings about that. •

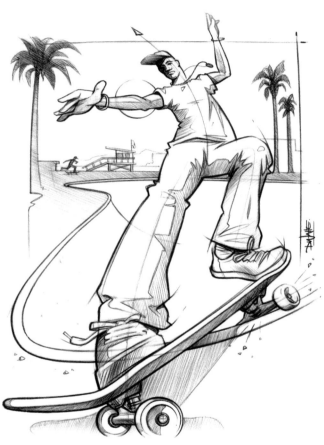

Frontside Feeble

Tension & balance

Doeke de Walle

As an automotive designer by trade and a skateboard illustrator by passion, Doeke applies the same principles: creating tension in volumes and lines and trying to capture movement in a harmonious composition.

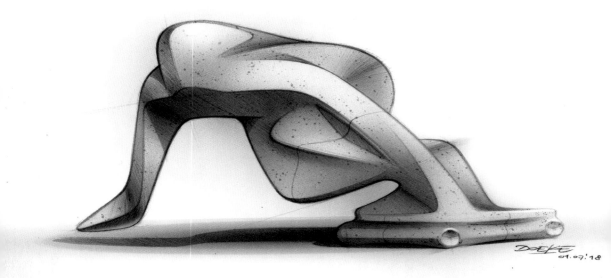

'I saw this picture of a downhill skater that fascinated me, because of the posture and the way he was leaning into the curve; it was such a beautiful balancing act. I immediately had the feeling that this could be a great sculpture. Over six drawings I abstracted the skater more and more, until I felt like I captured the essence of the movement. I think this shape would be great to sculpt from a heavy material like marble, to form an interesting contrast with the lightness of the posture.'

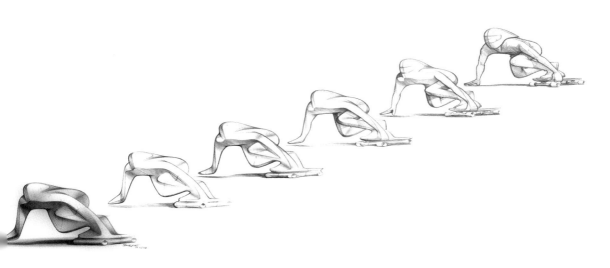

Lean abstraction

'Skateboarding is a lifestyle and a strong subculture with its own language, clothing style and art.'

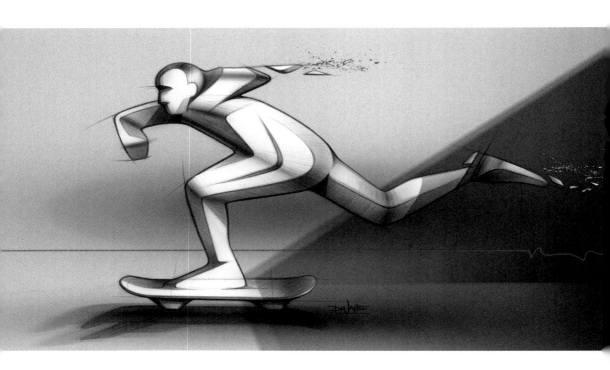

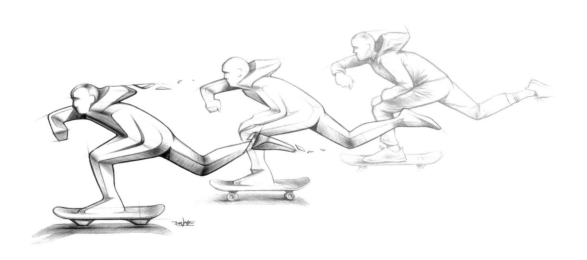

Keep on pushing abstract

Q & A

Doeke de Walle

Pforzheim, Germany

When did you start skateboarding?
I started skating around 10 years old, in 1988. My cool, older nephew skated and had a jump ramp, so I also wanted to try it. I started out, like many, on a plastic Penny board, just bombing down hills. My first professional board was a second-hand Santa Cruz, Claus Grabke board. It was the one inspired by Salvador Dali, with the melting clocks. I was immediately attracted to the strong skateboard graphics. What I loved about skateboarding was the sense of freedom it gave me and that it was so creative and not an organised sport. The fact that there are no official rules and that you can make up your own tricks is something I love. What also attracted me is that skateboarding is a lifestyle and a strong subculture with its own language, clothing style and art.

What is your medium of choice?
When I paint, I prefer to use acrylics in combination with spray paint on canvas or cardboard. I like the fact that acrylics dry quickly and that you can work on a bigger scale with spray paint. I have phases where I work mostly digital – mostly in winter, I've noticed – and phases where I work more analogue. I'll knock out several sketches in one week and then spend the next months colouring them in Photoshop. In the spring and summer, I love to paint more in my atelier.

You have a unique style. How would you describe it?
I think skateboard graphics, graffiti and my formal education as an industrial designer have all influenced my style. It's a big mash-up of influences, which show in my personal work. In automotive design, it's all about creating tension in volumes and lines and trying to capture movement in a harmonious composition. The same is true in my graffiti work. I have a very three-dimensional style, where I look for tension and balance in the composition of letters.
That's why I love drawing skateboarders as well, because you always find exciting tension in the body movements and great examples of balance, for instance when a skater locks in for a frontside K-grind on a handrail. When I draw skaters, I often try to stylise them in a more abstract way, so only the essence of the movement remains.

During the preparation for this interview, you told me that skateboarding has helped you in your artistic work. Can you please elaborate on that?
Style-wise, skateboarding culture has definitely influenced me, through graphics and magazines. But it has especially taught me, on a more mental/mindset type of level, that all good things take time, pain, sweat and, most of all, perseverance. Yes, I think the perseverance skateboarding has taught me brought me to where I am now in my career and in my

artistic work. You have to fall and get back up a hundred times before landing one trick, but each time you get a little closer to your goal. You have to keep a positive mindset, to keep yourself motivated.

What has been your proudest moment?
Skating-wise, my proudest moment was getting to a point where I was sponsored by a local skate shop in Utrecht, in the Netherlands, called E-Zone, and getting flow sponsorship from Vans. I was around 19 years old at the time and had just started studying Industrial Design Engineering in Delft, the Netherlands.

You work as a designer at Porsche. Is there anything from skateboarding that you apply to your day job?
I definitely apply the self-discipline that I learned from skating to my day job. In skateboarding, nobody tells you to land a certain trick. It's purely your own personal drive that pushes you to keep trying until you land it. This mindset helps me in my job as a designer. When I believe in a certain solution, I keep at it until I find a way. I try different approaches and alternatives until it works.
I also apply the power of visualising a trick in my mind, which I learned from skateboarding, to my design work. It helps when you can visualise a solution to a problem before you sketch it out. It's the principle of mind over matter.

Are there any other skateboard-inspired artists who influence you?
I really love the work of Andy Jenkins. I especially like the flow and dynamics in his skater illustrations. Growing up, I loved seeing his 'Wrench Pilot' series in skate magazines. It is very nicely drawn, with cool compositions and extreme perspectives. The black and white drawings have so much character and you can see that Andy truly feels the movements he's drawing. All the board graphics he and the creative team did for Girl and Chocolate, when the brands were first launched, are so iconic as well.
I also really admire Natas Kaupas for his creative and loose, flowing style of skating, which was so ahead of its time, and how he continued to apply his creativity in creating SMA and making it all the way to vice-president of marketing for Quicksilver.
I also have to mention Vernon Court (VC) Johnson, who was responsible for the Powell Peralta graphics in the Bones Brigade era. He really created a unique brand language and one of the most iconic board graphics ever to be made. Those graphics will always be ingrained in my memory.
It's a bit cliché, but I also admire Mark Gonzales's spontaneity in his art and his skating, especially because my work is much more calculated and technical. I respect artists and skaters who can tap into a very spontaneous form of expression.

Last question. If you could interview any person in the world, who would it be?
Natas Kaupas would be somebody that I would like to spend a day with and see how he ticks. He was one of the skaters I looked up to when growing up. I could not understand how he could ollie so high and spin on a freaking fire hydrant. I also found him pretty mysterious, because he didn't get that much exposure in magazines and wasn't a contest guy. I'd like to know what kind of mindset he has and how he's able to be so relaxed and innovative. •

06

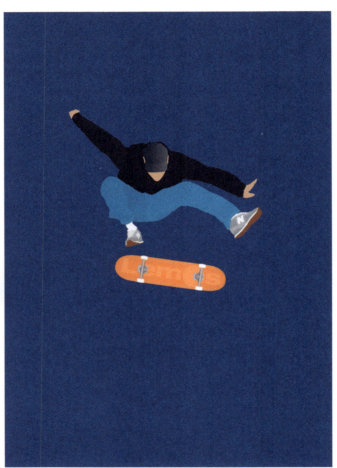

Tiago Lemos

True to life

Duncan Kirkbride

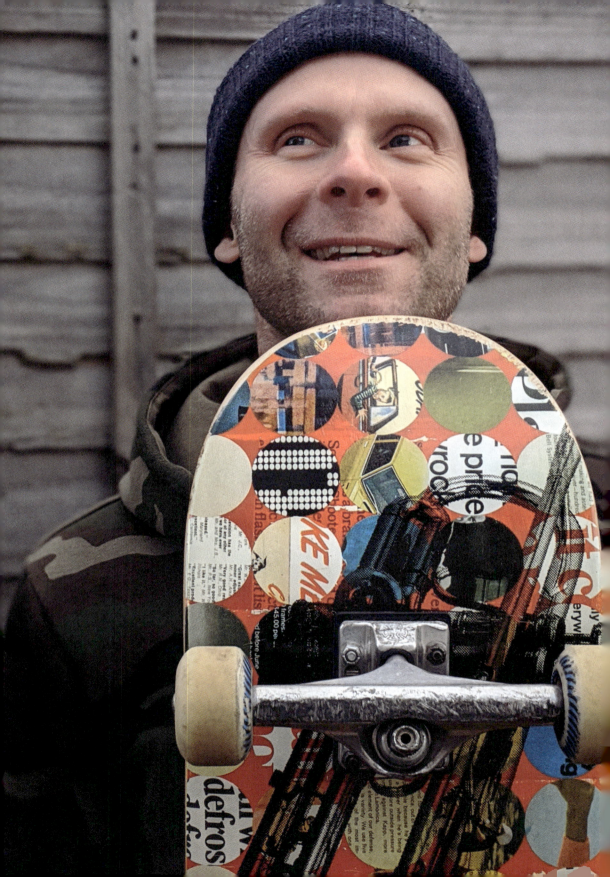

Duncan's approach is all about capturing real situations but stripping them back to the minimum amount of block-coloured areas and keeping to a restricted palette.

'When you need it, skateboarding's always there to save you in one way or another.'

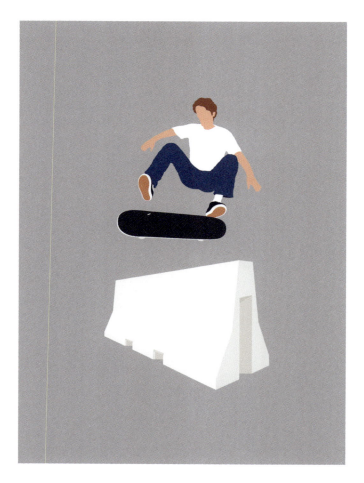

Pat Stiener

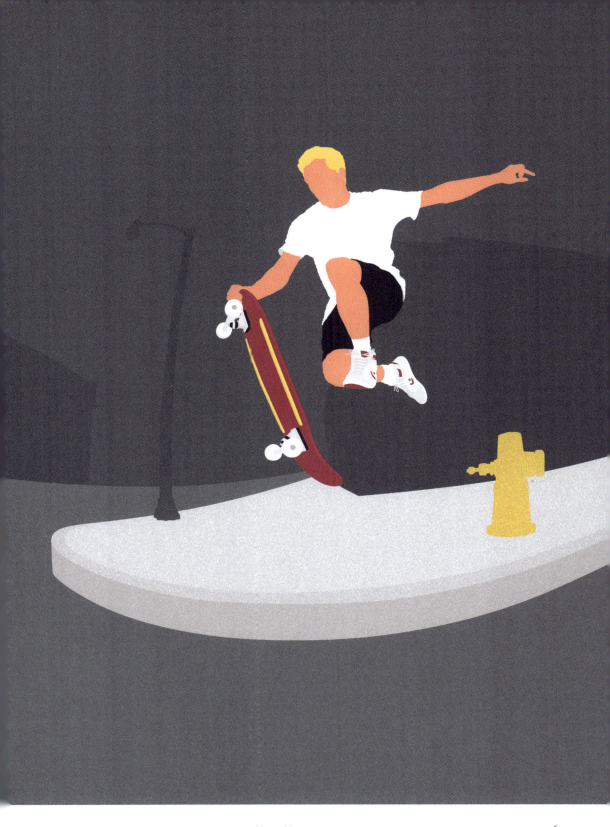

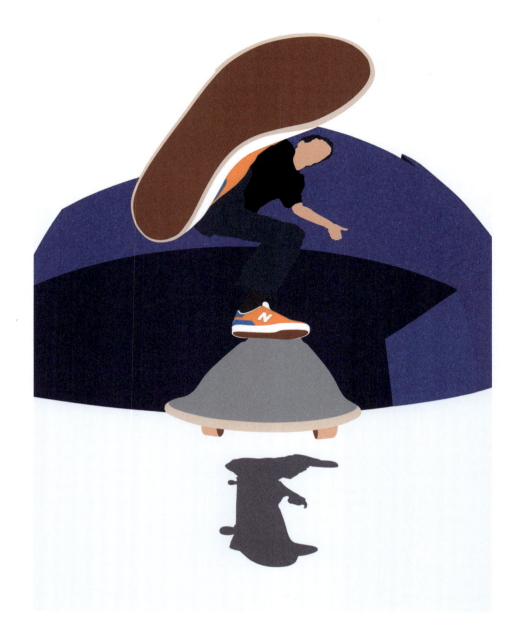

'I've always been a huge fan of New Balance Numerics filming and editing style, so when I saw this amazing still of Cookie I thought I had to have a go at illustrating it. I wasn't sure it would work, but it turned out amazing.'

Chris 'Cookie' Colbourn

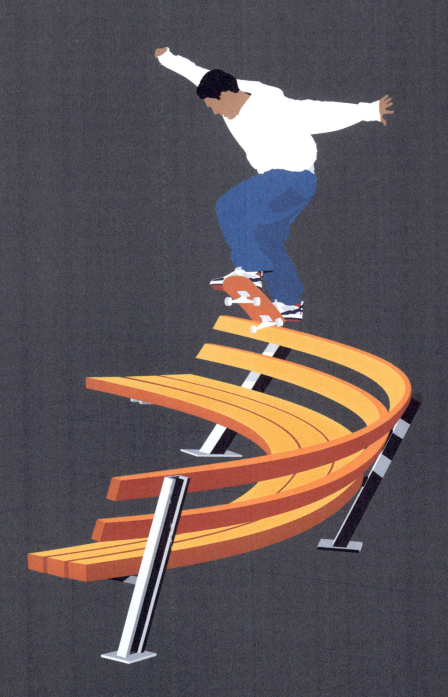

Tiago Lemos

Q & A

Duncan Kirkbride

Leeds, UK

How did you get into drawing?
I've been drawing ever since I was a little kid. I grew up drawing, building Lego and skating. They were the only things I truly loved, and still do. I guess the thing they all have in common is that there are no rules: you can do what you want, when you want, and your imagination and ability are the only limits. I remember once when I was a young kid, I'd spent all day drawing on this huge white sheet of wallpaper after our evening meal. *The A-Team* had just finished on TV and my dad and grandad were swinging me in a sheet (for fun!). When they stopped, my head was spinning. I started to feel sick, so my mum grabbed the nearest thing at hand, my drawing, and I proceeded to puke all over it! I still remember it so vividly now.

How would you define your style?
I'd say my style of illustration is very true to life. I view the process as solving a puzzle – taking a real situation, stripping it back to the minimum amount of block-coloured areas, while ensuring it's still clear what it is. I try to use colours that are true to life and keep to a minimal palette, while creating the depth and definition that the piece needs. Some of the line-drawn illustrations I've done, such as the Southbank pieces, are almost like architectural drawings with clear grids and vanishing points. There's something quite mathematical about that style of illustration that I love. It's so easy to get absorbed in the process and zone out from whatever's going on in life.

You started skating in the mid-80s. How did you get into it?
I think it was in 1984/85. My neighbour's grandson came to visit one day. He was a year or two older than I was. We found his uncle's old red plastic pencil, Penny-style skateboard in their coal cellar. We took it out on the street and figured out how to ride it. A few days later, I went down their drive, snuck into the coal cellar and took it. I was probably too young at the time to realise that was wrong, and actually stealing! I'm sure I must have got into quite a bit of trouble from my parents! Either way, I got to keep it and I still have it now. From sharing that one skateboard, over the next few years we ended up with a pretty big crew of around 15 kids, just from our street and all with skateboards. We used to skate on the street all day, every day – it was a pretty magical time!

How has skateboarding influenced your work as an artist?
I think the exposure at such a young age to so many graphical styles and the punk aesthetics of the 80s mags, such as Skateboarder and RAD, have always been a massive influence on my art and the things that catch my eye, ever since I was a child. The boards and T-shirts that even now have those big fun character graphics like the early Powell, Santa Cruz and Blind ones are still what I'm drawn to and, like many others of my age, I've started to collect a select few reissues.

Has your work on illustrations also shaped how you skate or how you feel about it?
As a skater, as we all know, we look at the world and its architecture in a very different way to the average person. We're always looking for a spot to skate and picturing what we could do on it. We see spots that are waxed-up and know they've been skated. I guess it's the same with design and illustration – you're always looking out for skate graphics, brands or even skaters that you like aesthetically or that align with your sensibilities.
Having some of my work up as part of a skate art show at a gallery called UpCo in Leeds, UK, earlier this year was amazing. And as I'd just been made redundant, the timing couldn't have been better. It gave me something super positive to focus on and be involved in – when you need it, skateboarding's always there to save you in one way or another. It was through doing the show that I got talking to someone who ended up hooking me up with my new job!

Are there any other skateboard-inspired artists that influence your work?
I wouldn't say that she influences my work, but Lorna Goldfinch, who I've followed on Instagram for some time, had some amazing paintings at the same art show that I did at UpCo. Her work is inspiring as to what can be done with skate-related art. She paints DIY skateparks in sketchbooks and on board. They're just so good, and it's such a cool and different way of looking at spots, and seeing what can be done with a traditional medium like paint.

Are there any board companies grabbing your attention with their graphics?
I love brands whose graphics don't take themselves too seriously and are just bright and fun. Sean Cliver's Strangelove has to be the best current example of this and I guess it goes back to the heritage of all the boards he's designed over many years for so many brands. Another brand I love is a UK one called Blast Skates. They have a really simple brand, with a fun character mascot as their emblem, and generally a really simple colour palette, usually black, white and yellow – what's not to love!

Last question. If you could interview any person in the world, who would it be?
Wow, that is something I've never thought about before. If I could be sent back in time to the mid- to late 60s, à la *Back to the Future*, I'd love the opportunity to meet John Lennon at the height of Beatlemania! I've always been a huge fan ever since I was 12 or 13. Not a very original answer, I know, but that'd definitely be a fun interview to do. •

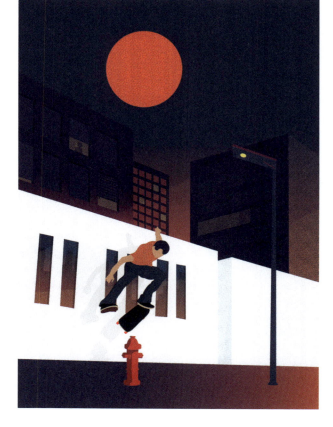

Ollie North from the North

Plain graphics

Erik
Ziegler

073

Erik's illustrations combine a heavy influence from skateboarding with the history of graphic design. The result is the creation of striking international-style poster pieces with bright colours.

nosebonk.com 〜〜 @nosebonkgraphics

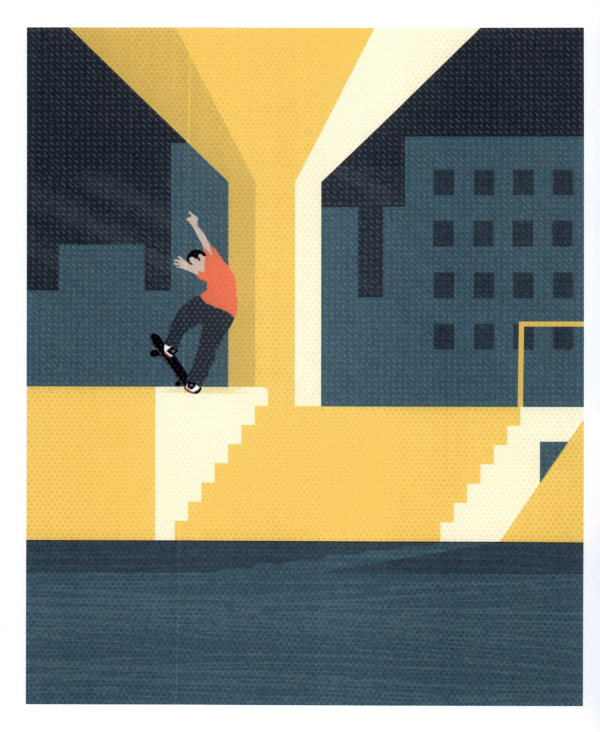

'This fine art print captures John Rattray's stylish frontside bluntslide at the iconic Southbank, London. A tribute to one of skateboarding's most legendary spots.'

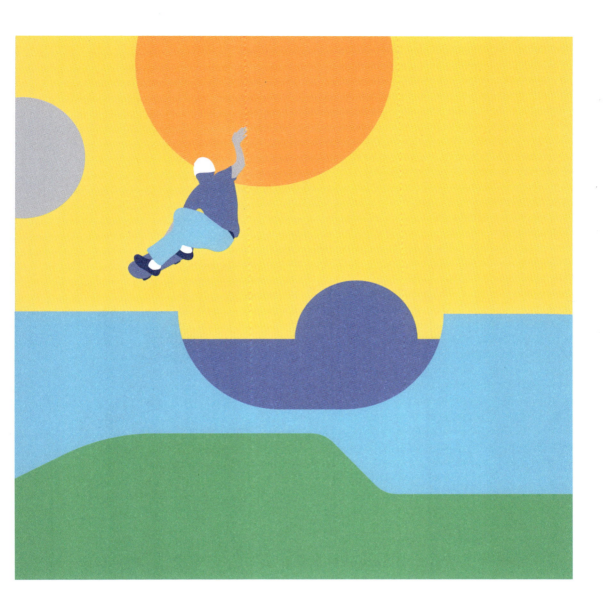

'This artwork combines the raw power of Pedro Barros' skate style with a minimalist illustration approach. The color palette is inspired by a classic German designer, blending vibrant hues that evoke a Brazilian essence. This piece captures the dynamic energy of Barros' skating while showcasing the beauty of minimalist design.'

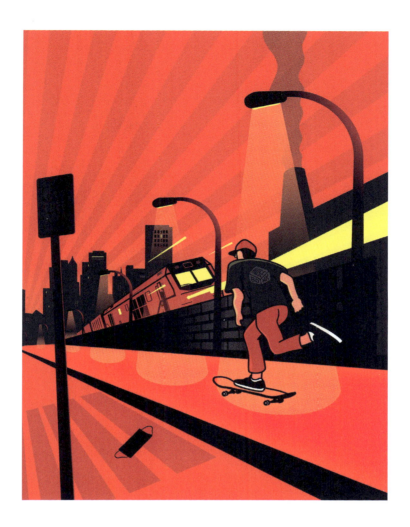

'This poster, inspired by the bold colours of Russian avant-garde, symbolizes the end of isolation for skateboarders. It captures the image of a skater pushing towards the city, a metaphor for the joy of reclaiming the streets. During those difficult days, when Spain was under one of the world's strictest lockdowns, I remember the need to skate anywhere. This artwork expresses the happiness and liberation of finally being able to push back to the city and reconnect with urban life.'

Q & A

Erik Ziegler

Madrid, Spain

You create skateboard graphics after work. How long have you been doing this?
I'm a graphic designer by profession, and this has been my craft and passion for a long time. A while ago, when I started leading design teams, I could no longer design at work myself. Three years ago, this pushed me to integrate design into my life outside of work by combining it with my other passion: skateboarding. Since then, I've been creating skateboard graphics, allowing me to express my creativity in a more personal way. That said, I'm not an illustrator – this journey is also helping me evolve my drawing skills.

What came first: skateboarding or drawing?
I always drew as a child, or at least that's what my mother says, but I can't remember my youth without skateboarding. I definitely think that skateboarding was more relevant in my early years and inspired me to pursue graphic arts and illustration.

How did you get into drawing?
I have a memory from childhood when we learned to draw in perspective at school. I would spend entire afternoons with a ruler designing sofas. I'm not sure why I didn't become a furniture designer, but I think this experience helped me understand shapes and compositions. I studied Fine Arts in Bremen, focusing on sculpture and later on design. Sorry, I don't have a specific answer – it's more of a journey than a single moment. I started NOSEBONK and really began drawing again during the Covid pandemic, which gave some of us only one good thing: time.

What is your medium of choice?
I start with rough ideas, writing text and phrases or basic sketches. I really enjoy the process and those initial abstract moments. Then, I move on to composition sketches in a notebook using colours and basic strokes, and finally, I take it to digital. My final medium is the iPad, as I initially couldn't work on my Mac because it reminded me too much of the office.

How would you define your style?
I've never really thought about it. As I see myself more as a graphic designer than an artist, I don't think I have a personal style. I usually give myself a brief or an idea and try to convey that concept using any style that works for me. I do struggle more with figurative drawings, so I suppose it leans more towards plain graphics.

Your skate illustrations all have very different styles, influenced by different artists and eras. Where does this need for diversity come from?
It probably comes from the fact that I'm a designer. On one hand, I have multiple influences from early skate graphics like Powell

Peralta, Santa Cruz, New Deal or Zorlac. On the other hand, there's the entire history of graphic design, which is much broader. These styles are completely opposite, and I can't choose between them. I'm fascinated by both an international-style poster and the drawings of Jim Phillips or M.C. Escher at the same time.

How has skateboarding influenced your work as an artist?
Skateboarding has influenced everything I do in my life, shaping my way of being and thinking. As an artist, both design and skateboarding are crafts that require mastering through countless hours of practice before getting to the final result. It has taught me to enjoy the process, even when failing many times along the way.

What has been your proudest moment?
I'm not someone who seeks pride, but workwise, I once shared a stage with Steve Wozniak for a talk on user experience in front of 1,000 people – it was really scary but rewarding. Skate-wise, I was proud of my NOSEBONKS, Nosepicks and North Ollies. These days, I'm proud when I manage to create skate graphics after work.

Have you had any embarrassing or funny moments along the way?
Once, a client criticised a digital work of mine, an app design, saying it didn't look good and needed more contrast. I agreed, and four days later, I returned, claiming I had adjusted the contrast and increased the greens he wanted. The meeting went well, but in reality, I didn't change a thing!

If you could pick between being a pro skater or a full-time artist, which would it be?
Another tough one! It's hard to believe, but I've been thinking about this for a week. Conclusion: Without a doubt, as long as my bones hold up, I'd choose skateboarding.

Are there any other skateboard-inspired artists who influence your work?
All the skate artists from my youth skate time from the 80s and early 90s influenced me, but even more classic designers like Müller-Brockmann, Paul Rand, Herb Lubalin and Wim Crouwel, among others. I missed many of the skate brands and designs from the mid-90s to 2012, a period when interesting brands like Chocolate, Girl and Alien Workshop were blending graphic design with less illustration. Looking at them now, I'm sure they would've been a significant inspiration.

Are there any board companies grabbing your attention with their graphics?
Some new skate companies are embracing the graphic trend known as New Ugly or graphic brutalism, but I'm too old to relate to those – I still value good craft and beauty. It can be fun but never ugly, in my opinion. I appreciate companies like Tired that achieve a bold brand identity with great execution – all their graphics look beautifully tired. Blast Skates in the UK is also amusing – I love their mascot. Additionally, Framework, with whom I've worked, is trying to bring back beautifully designed decks inspired by more classical graphic design.

Last question. If you could interview any person in the world, who would it be?
Probably Matt Hensley. I think he's the only person that made me feel like a groupie in my life! As a kid, I was greatly influenced by his skating style, and I believe he still stands as one of the best skaters in history today. •

08

Cruising

Analogue charm

Hannah Forward

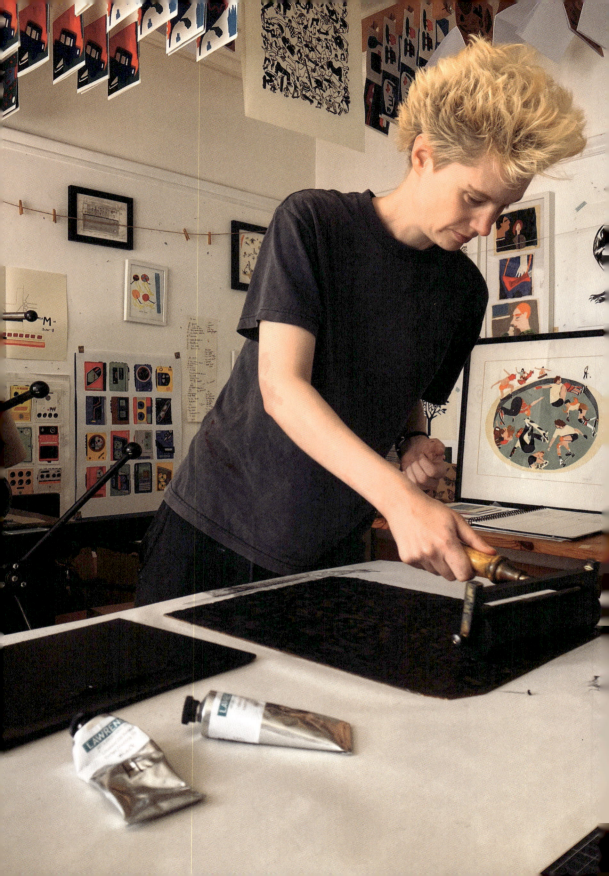

Hannah is a linocut and woodcut printmaker, which means she makes the lines of her drawings sharper and 'blockier' by simplifying everything down to the essential. But she is also a painter, which allows her to be more free-flowing, using more colours and subtle tones. Both disciplines keep her excited about the other.

'I actually don't mind little mistakes; it's all part of the imperfect, analogue charm.'

'Bay Area is inspired by the work of John Thatcher, a California-based photographer who takes dreamy, nostalgia-soaked photos, lots featuring skaters.'

Pool Skaters

'Orange County I made from combining a few different found photographs. I love to paint very un‑remarkable‑looking urban scenes, it was fun to add a skater into that kind of boring‑looking landscape.'

Orange County

'I'm always interested in the skate brands that exist specifically to encourage and support LGBTQ+ skaters.'

Q & A

Hannah Forward

Brighton & Hove, UK

You are a printmaker and painter. How do you decide if something is going to be a linocut/woodcut print or simply painted?
I usually make my prints by gathering together lots of images and making a composition I like from them, so it's almost like a collage, which I'll then make into a drawing. I'll then turn this into a print by separating the colours into different layers, which I'll then transfer onto the block of linoleum or wood, carve out and print, building up the layers gradually. With painting it's more like its own little scene, complete in itself. I paint from photographs so whenever I see something I like, perhaps on Instagram or a still from a skate video I watched, I'll add it to my inspo archive.

How would you describe your style?
Bold, colourful, illustrative, positive with an edge of humour.

What were your first steps as an artist?
I was a shy kid so always felt so grateful whenever I could absorb myself quietly in painting and drawing. I went on to study graphic design for my degree and learnt a lot about colour and composition. I got a job working for an art supplies company and discovered printmaking. I took a short course in linocut and woodcut printmaking and everything just clicked. Painting started out sort of as a side hobby, but now I spend a couple of days a week painting. I love how different the two disciplines are, and going between the two keeps me interested and excited about each one.

You include skateboarding in some of your illustrations. Is there a special connection?
I grew up in the 90s with a brother who went through a short, intense phase of being very into skating so it was through him that I developed an interest, more from an observer and appreciator point of view than actually wanting to skate myself. He'd lend me his skate mags to draw from and we'd watch skate videos together. Something about skating felt so interesting and creative to me, like a sport invented for outsiders and weirdos or people that didn't fit in. I remember feeling intimidated but so intrigued by the skating area on London's Southbank. I've always had an appreciation and admiration for skate culture, so I want to show that through the art I make.

What is it about skateboarding that inspires you?
For me I think it represents a kind of essence of the freedom of youth, and maybe a bit of nostalgia for that pre-digital time when everything felt simpler. I also love how with skating you have to attempt the same trick over and over and over again before finally achieving it. That level of mindless practice over something that's so hard to achieve but in the end, if you manage it, looks kind of effortless and beautiful. That's exactly the same with art making.

What has been your proudest moment?
I think designing and printing the Pool Skaters linocut, which was an early multi-block linocut I made back in 2016 when I got myself a press off eBay and started printing at home. It's still one of my favourite prints I've made.

Have you had any embarrassing or funny moments along the way?
Actually, you can see a mistake I made in the Pool Skaters print. I forgot to carve out the green from one of the faces so he's looking a little peaky. A rookie error! But I actually don't mind little mistakes; it's all part of the imperfect, analogue charm.

Are there any specific skateboard brands or board companies you follow because of their aesthetics?
As someone who is queer and gender non-conforming, I'm always interested in the skate brands that exist specifically to encourage and support LGBTQ+ skaters and that want to help make skate spaces friendlier places for anyone who doesn't happen to fit into the classic hetero male mould. I follow Unity and Glue on Instagram – they do really important work in this area.

Do you think skateboarding takes a leading role in the support of the LGBTQ+ community compared to other 'sports' or is there more that can be done?
I think skateboarding communities have always been a haven for anyone outside the mainstream, and of course there's always more work to be done to make it more welcoming to anyone who wants to be part of it. The male dominance of skating has massively changed over the last 20 years. Where I live in Brighton, you see young girls with their friends skating all the time – it's completely normal. The skatepark at The Level has much more of a mixture of genders and ages now compared to when I first moved to Brighton in 2003. So huge progress there. I think the next step is to make skating feel inviting and inclusive for absolutely everyone. For LGBTQ+ skaters to feel intimidated or in any way like there isn't a real place for them in mainstream skating, a sport that exists for outsiders, that just doesn't make sense to me – it shouldn't be that way. I think binary gender categories for skating competitions is a big example of this. I remember watching this skate video back in something like 2001 and Amy Carron saying, 'A lot of people trip about, like, "girls, boys…" you know. Just skate. There's not really a difference.'

Last question. If you could interview any person in the world, who would it be?
Leo Baker. He seems like such a great person and is such a fantastic role model for young LGBTQ+ skaters. I'd really just love to meet him. •

091

09

Ollie Over Hedges

That guy

Henry Jones

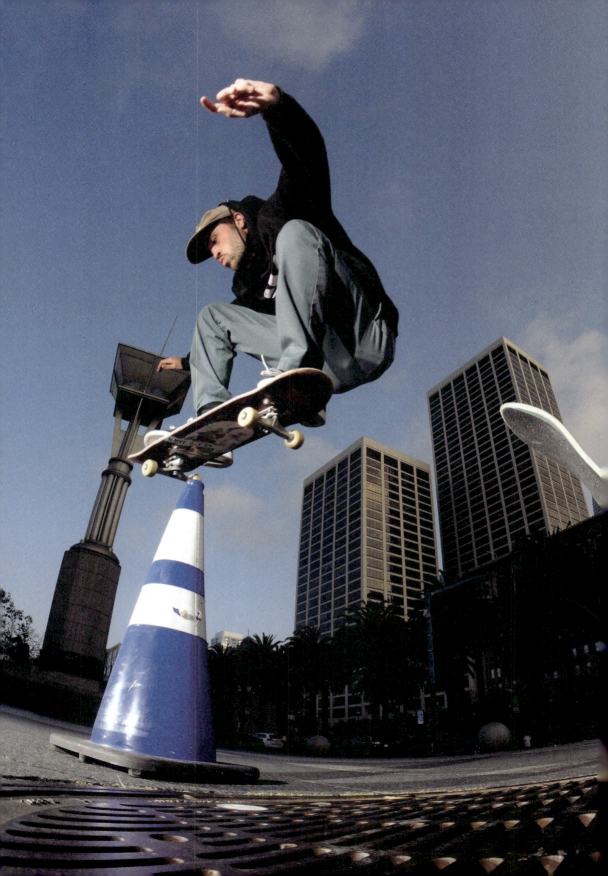

There are not that many skateboard comic artists around. Henry Jones is one of the few who has also made a name for himself with his warm, positive and sometimes satirical take on the skateboard community and industry at large.

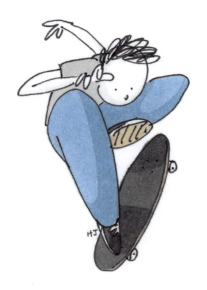

096 360 Flip Over Bumps

'The characters I draw skate in the style that I secretly wish I had.'

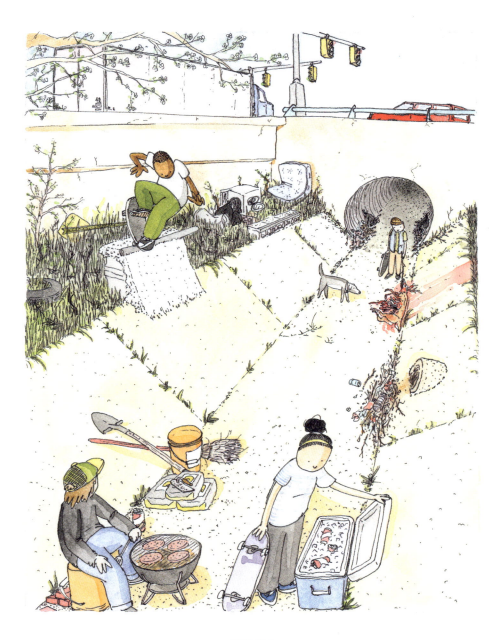

DIY Ditch

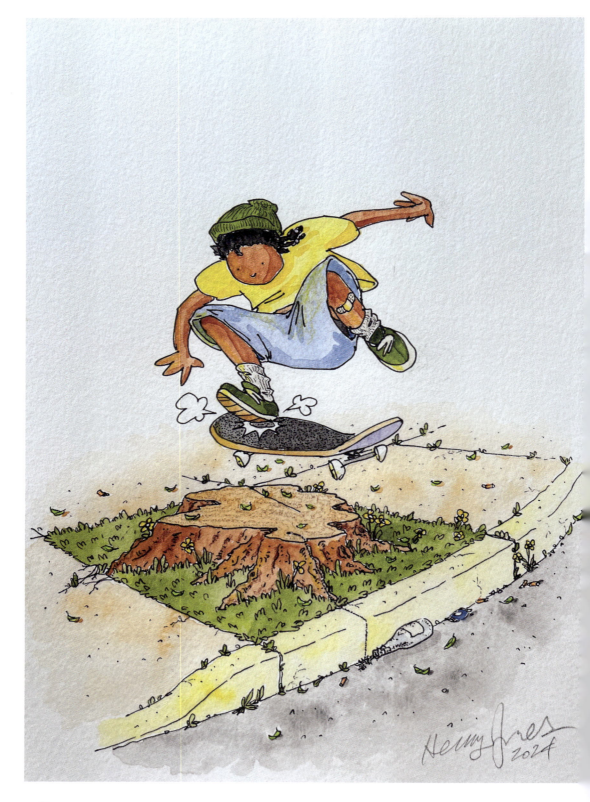

Curb Cut Stump

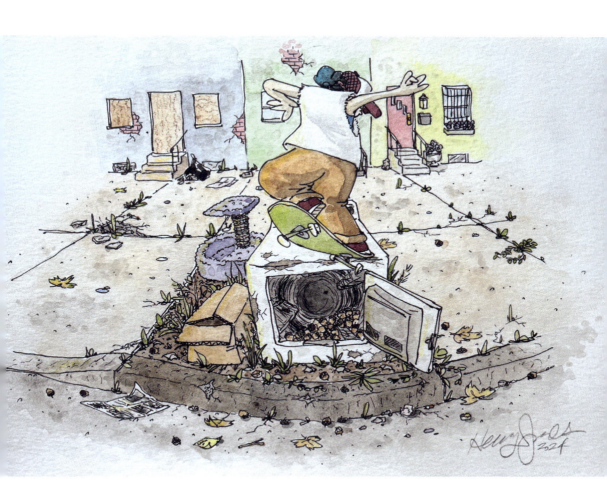

'When I first started doing more skateboard-related art, I was definitely influenced a lot by Mark Gonzales.'

Golden Hour

Secret Spot

Q & A

Henry Jones

Pennsylvania, US

You are a talented skateboarder, have worked in a skate shop and are a full-time artist. From the outside, it looks like you are living the dream. Is there anything left on your bucket list?
I think there's plenty left. I certainly would like to travel more, hopefully skating while I'm at it. I guess you could count maintaining a career as an artist as a bucket list item, since there's always a level of uncertainty to it. I'd be stoked if I'm still able to do that in a fulfilling and meaningful way down the line. There are definitely brands, too, that I think it'd be cool to work with in the future. I've been making a point of going out filming more so I can put out more footage. I think that's something that is really important to have go hand in hand with my art for as long as I'm able to do it.

How did you get into drawing?
Both of my parents, at least while I've been around, have always made a living as artists and graphic designers. So, it's always something that I've been around, seen someone doing, or done myself. Sometimes less frequently than other times, since I really focused more on skating during my teenage years. I think I was too young to remember not drawing, since I just had access and encouragement to start so early on.

What is your medium of choice?
I typically like to use just pen and paper. Using a pen, I think, gives me the best fluidity to the motion of my lines. The lines are my favourite part of the style I use. Whether or not I colour things digitally, with watercolour or ink markers, kind of depends on the project.

How would you define your style?
Loose, gestural. One of the most important things I did that contributed to helping me develop and differentiate my style was taking a figure drawing class.

There are not many skate comic artists out there. Is there anyone you looked up to when you started?
When I first started doing more skateboard-related art, I was definitely influenced a lot by Mark Gonzales and other artists whose work I was familiar with from board graphics, like Marc McKee, Sean Cliver and Michael Sieben. Working at a skate shop in a college town provided me with more than enough content to branch off into the more comic sort of style that I think a lot of people are familiar with.

You created your main nameless comic character you refer to as 'that guy I draw' in 2013. Since then, you've worked with big brands like Adidas and designed one of their shoes, provided graphics for board companies, etc. Are you still pinching yourself sometimes about how you got here?

All the time – it's hard to express how much I appreciate all the support I've received over the years for my art. Being able to remain involved with skateboarding in an impactful way on a daily basis like this isn't something I ever thought would be possible, so I'm always in awe that I still get to do it and hopefully will continue to.

How has skateboarding influenced your work as an artist?
So much of my art is meant to capture the motion of skateboarding or at least display a sort of understanding of the physics behind what I'm trying to draw. By actually skating, I think that understanding translates into my art in a way that is identifiable and appreciated by other people who do it. It also allows me to play with movement in a little more stylistic or hyperbolised way.

Has your work on illustrations also shaped how you skate or how you feel about it?
I wish it were that easy *(laughs)*. I personally think that my style on a skateboard isn't the most aesthetically pleasing, but maybe that's just me being harsh. The characters I draw skate in the style that I secretly wish I had.

What has been your proudest moment?
I'm not sure if I can name just one. It meant a lot to me to have a full part in my shop's video Fairman's 4. Even just having the opportunity to work at Fairman's Skate Shop under Dave Fairman is something I'll always be proud of. All of the art shows over the years that people showed up to, getting to design my own shoe colourway for Adidas is definitely up there, all of my art that has made it to board graphics... I could go on, and hopefully there will be many more proud moments to come.

When did you decide to go all in as a full-time freelance artist?
I remember it pretty vividly. I was standing in the bathroom of my apartment down the street from Fairman's Skate Shop in West Chester, PA, where I had slowly been working less and less until I was only working the 11-hour Saturday shifts. I thought to myself, 'Wait a second, I can make more money doing art for a few hours today than I will standing in the skate shop all day getting paid 11.50 an hour.' So, I called the other person working that day, who happened to be my friend Mike (sorry, Mike), and told him I wasn't going to make it in that day and that it was probably time to take me off the schedule. That was January 2016 and I've been doing art full-time since then.

Would you switch to being a pro skater if you could?
(Laughs) That used to be the dream. If I could keep doing the sort of low-tech, low-impact skating that I like and someone wanted to pay me a living to do it – sure, why not? I don't expect that, though. My current gig might be the next best thing: I get to remain involved, and no one expects me to throw myself down anything.

Are there any board companies grabbing your attention with their graphics?
I really liked the *Where's Waldo*-inspired series that Clay Halling did recently for Real Skateboards. I grew up looking through those and *I Spy* books, so those were a nice little hit of nostalgia.

Last question. If you could interview any person in the world, who would it be?
Hayao Miyazaki, to learn a little more about storytelling. •

01
02
03
04
05
06
07
08
09

10

Angle

Chaos & chill

Hiroki Muraoka

Hiroki's acrylic paintings are all about how the lines connect with each other. Some of his illustrations look like puzzles. A lot is going on, but it's all in tune though as he masters chaos and chill through patience.

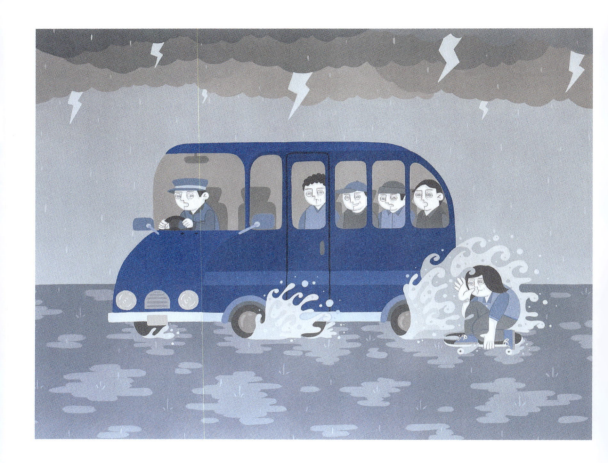

'I think it would be great if there was a scene like this, and I imagine the kids on the bus thinking skateboarding was cool and taking up skateboarding. It's raining and cloudy, but I wanted to draw a picture with a positive feeling.'

Street tube

Chaos

'Even when skating, it can take a long time to find a spot and think about what to do. Patience is often important.'

Shoot

'When I wanted to draw a seaside scene, I found a long and narrow panel and decided I wanted to draw a coconut tree. So I thought it would be a good story to put a skater trashing on an embankment underneath that. I like drawing pictures that show how good it would feel to have a landscape like this.'

Trash

'I feel like the way my lines overlap creates a mysterious link between this world and the painting.'

Q & A

Hiroki Muraoka

Tokyo, Japan

You're a very talented skater and artist. If you could go pro, which one of the two would you choose?
Artist. This is because there is a world out there that I don't know about, and professional artists have a lot more opportunities compared to skateboarders. So, I'm curious to know more about it.

You started skating at the age of eight. Did your older brother get you into it?
I often skateboarded with my brother. He took me to many places and taught me all the things.

When did drawing come into the picture?
I don't remember, but I guess I was in middle school. There is this picture I drew a long time ago that's hanging up in my parents' house.

What is your medium of choice?
Nowadays it's acrylic.

How has skateboarding influenced your work as an artist?
I think I apply the same things I do when skateboarding, thinking creatively about how to use spots, what tricks to use to get the most fun and interesting footage, and how I skateboard. How should I show it to get the viewer interested, and how should I convey it to them?

Has your work on illustrations also shaped how you skate or how you feel about it?
Some artworks take a very long time to create, from starting with a rough drawing to turning it into a work. Even when skating, it can take a long time to find a spot and think about what to do. Patience is often important.

In an interview you described yourself as 'chaos and chill'. How do you describe your style as an artist?
I think I often create with connection in mind. I also have connections with people. It's just that the lines are connected. I feel like the way they overlap creates a mysterious link between this world and the painting.

Have you had any embarrassing or funny moments along the way?
It's a bit embarrassing when someone praises a piece of work that you don't like, but everyone has different sensibilities and it's interesting. When I put on an exhibition, it's fun to see everyone has different opinions.

Are there any other skateboard-inspired artists who influence you?
Geoff McFetridge is my favourite. His works are stripped down and have no facial expressions, making them very simple and pleasant to look at. And I think it's difficult to do that. There's a Japanese artist named Shigeo Fukuda, whom I'm also a fan of. I think Geoff was probably influenced by Fukuda as well.

What does your dream assignment look like in terms of brand and scope of work?
Actually I want to take a big picture with a big company. My wife is also an artist and a designer, and she said she likes Shiseido and wants to work with them. It is true that all the work that Shiseido has created is amazing and I would be happy if I could work with them.
I would like to try working with a big brand like Hermes.

Other than Traffic, who you're riding for, are there any board companies grabbing your attention with their graphics?
Soi is a friend, a cool skater and a cool artist too. My favourite board brand for its graphics is Magenta.

Last question. If you could interview any person in the world, who would it be?
M.C. Escher. I'm a huge fan and I'm curious about what he was thinking. •

11

Evan Smith Macau Kickflip - guest background art by Jess Holland

Stop. Motion. Skateboard. Animation.

Jack Hyde

Jack has been a freelance animator for almost 20 years, creating unique and eye-catching stop motion animations for a wide variety of internationally recognisable brands. In 2022 he launched the animated skateboard series *Pen Pals* with videographer Chris Ray.

jackhydeanimations.co.uk ~~~ @jackhydeanimations
jackhydeanimations.bigcartel.com

'For *Pen Pals* episode four I wanted to experiment with a kind of flipbook style of animation for one of the scenes. I painted the background image and then created a bunch of pop-up drawings that flip over to create the movement of the trick. This poster uses one of the many cutouts placed over the painting.'

Evan Smith - heelflip

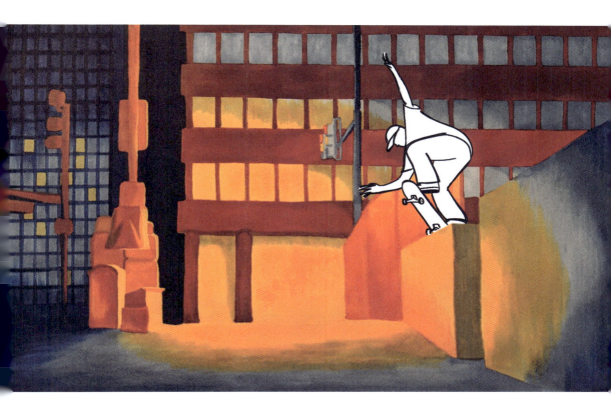

'The Tiago night scene is from episode two of *Pen Pals* and it's the first time I collaborated with the talented Jess Holland. She painted the background image and it's a bit of a homage to *Nighthawks* by Edward Hopper – a painting that we are both huge fans of.'

Tiago Lemos at Night - guest background art by Jess Holland

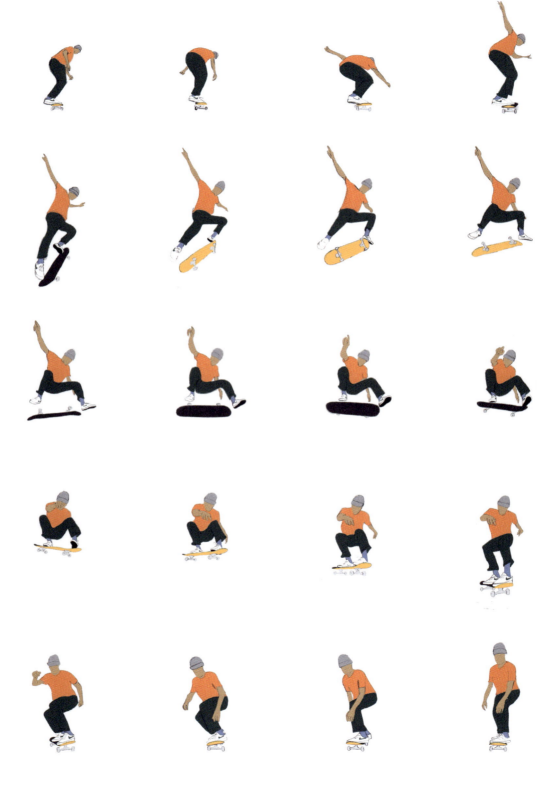

Luan Halfcab Flip

'Stop motion is all about patience and I don't know if I could have stuck with it if I hadn't spent so much time learning to skate.'

'This was one of the first times I laid out some of my animation drawings in a sequence. I love the way it forces your eyes to move across the page, animating the drawings in your head. The thing that really makes this sequence work is the picture-perfect catch by Luan on the flip – it makes the whole thing flow so smoothly.'

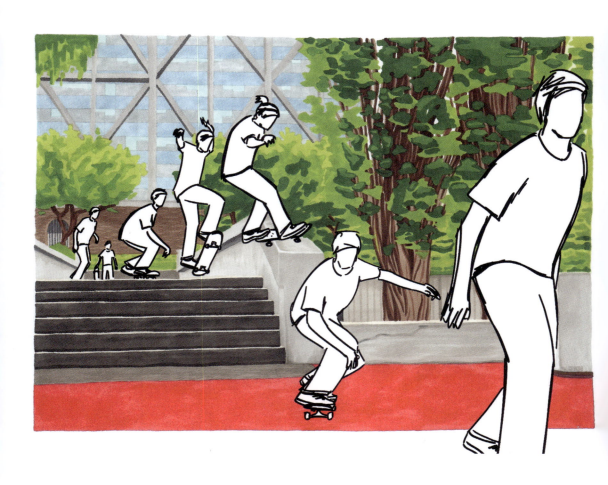

Mike Carroll at Hubba Hideout - guest background art by Jess Holland

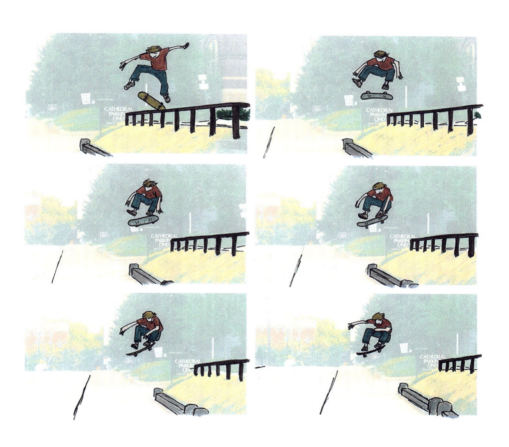

Evan Smith - kickflip (6 grid)

Q & A

Jack Hyde

Devon, UK

You're a stop motion artist animating pro skateboarders, but you also do skateboard illustrations. What came first?
I started animating around 2007 and it wasn't until many years later when I was making skate animations that I realised that the images looked cool when laid out as a sequence. I had made a few small zines and DIY print packs, but it wasn't until the pandemic that I released something more substantial. There is a suicide prevention charity in the UK called PAPYRUS and they're very important to me, so I decided to try and raise some money for them. I got some letterpress/hot foil prints made up and they actually ended up selling really well, so since then I've continued releasing new print runs every year with all the profits going to them.

From an interview, I learned that *Thrasher Magazine* put one of your stop motion clips on their Instagram and it took off from there. Were you surprised that you could make a living from these animations?
Yeah, that's right – as much as social media has its issues, it was an incredible example of how it can lead to one person's work being seen by people all over the world. I ended up getting contacted by a bunch of brands wanting similar animations, so it was strange to realise that I could actually earn a living from this really niche thing. I owe a lot to them for posting that. I was fully freelance for a few years and it went well, but in the end I realised it wasn't for me. Now I have a balance where I make animations for a university here in the UK part-time and then I freelance the rest of the time. I think it's really important to find the right balance for yourself.

What is your medium of choice?
A lot of my animations are drawn or painted in grids, so the sequences naturally lend themselves well to illustration. It allows the movement to be conveyed when looking at a static layout. There's a letterpress cafe near me and I love getting my simple line drawings printed in their traditional printing press. The debossed texture is beautiful and having the prints made one by one like this almost feels like an extension of the analogue stop motion technique. I think the processes really complement each other.

How has skateboarding influenced your work as an artist?
First and foremost: patience. Anyone who has skated knows how much time and effort you have to put into doing the same thing over and over, just to learn to ollie or kickflip. Stop motion is all about patience and I don't know if I could have stuck with it if I hadn't spent so much time learning to skate. I think it's a valuable lesson I learned early on from skating – finding out that the progress you thought you made on something that you've spent hours and hours on isn't as much as you first thought, but knowing it was still worthwhile.

What has been your proudest moment?
Having my work exhibited at the Arles photography festival (Rencontres d'Arles) was by far my proudest moment. To be asked to create a piece for such a prestigious festival was very surreal. I know that none of us need to have our work 'legitimised' in any way for it to be considered art, but even so, I never thought I would see my name on a poster for an event like that.

Are there any other skateboard-inspired artists who influence your work?
Leon Washere is an artist whose work I adore. It's not strictly stop motion, as I think he actually scans his paintings in, then reassembles them in a timeline, but it's a similar analogue workflow. I think one of the reasons I love his work so much is that I can appreciate the time and patience needed for each piece he creates. It's a shared pain.
I also really love Eloise Dörr's work. She's an artist from the UK and creates these really fun, beautiful skate illustrations. I'm a big fan.

You've worked for many established skateboard companies. What would your dream assignment look like in terms of brand and scope of work?
It's been amazing. It's still mad to think how much I loved those brands growing up and now I get to create stuff for them. I hope there are up-and-coming artists reading this who are going to end up working for the companies that they look up to, because it's such an incredible feeling when it happens. I'm not sure I have any dream brands, really; I've ticked off a bunch of my favourite ones and I'm more excited to see artists who I've chatted to, and maybe offered some advice to, go on to work with those companies – that's happened a few times recently and it's really lovely to see. I think I'm now at the stage where my dream assignment is more about the freedom to create what I want and to have fun doing it – something I luckily now get through the *Pen Pals* video project.

Last question. If you could interview any person in the world, who would it be?
I'd love to chat to a bunch of the people who inspired me, especially from growing up playing in DIY punk bands – people like Ian MacKaye, Kathleen Hanna, etc. They shaped a lot of my life, but honestly, what could I ask them that they haven't already answered a million times before? I wouldn't know what to say. So with that in mind, I'm gonna have to say my dog – I just wanna know that he's happy. •

12

Skatefreak

Eye-popping

Jimbo Phillips

Jimbo specialises in bold, eye-catching illustrations for skateboards, music, clothing and toys. You'll also find some of his works hanging in a downtown art gallery. His father Jim is an iconic skateboard artist but Jimbo has ventured off with his own unique style for over 30 years. The family legacy does not stop there however.

'Being a part of skating is more than the act of riding.'

SkateCreep

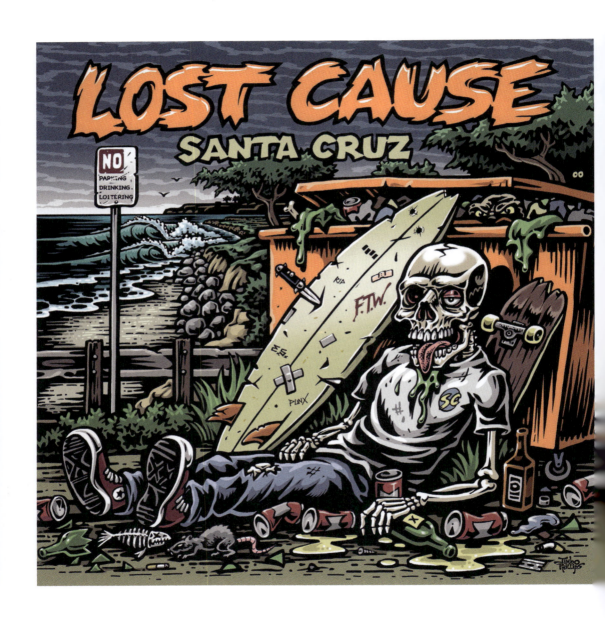

Lost cause

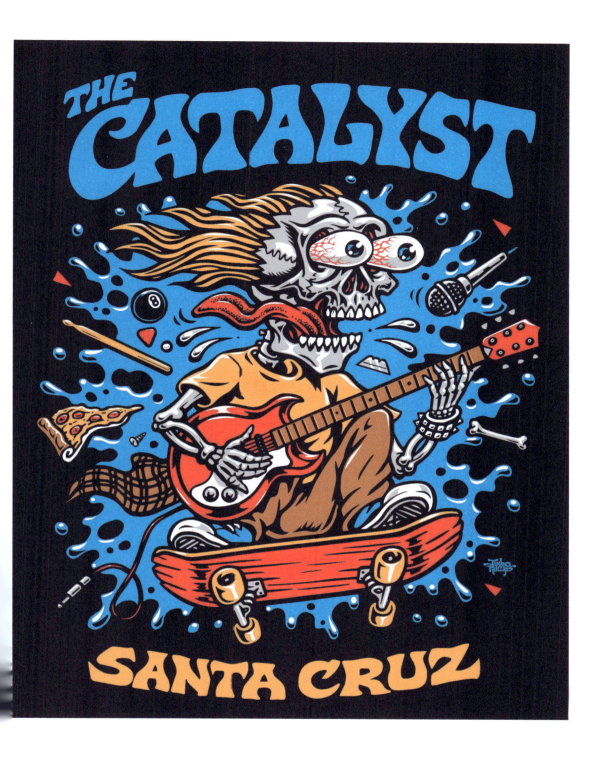

Q & A

Jimbo Phillips

Santa Cruz, US

Your dad is a legendary artist in the skateboard community, and you obviously followed in his footsteps. Ever thought what you would have become without his influence?
I've been drawing ever since I can remember. My dad would be doing art and I would pull up next to him and start drawing. He would give me tips and encourage me. Later, when he needed help in his studio, he hired me to draw a comic series and, once I got paid for drawing, I never looked back. I knew that's what I wanted to do.

He took you in as an apprentice from where you started your own graphic art business. Did you ever go to art school or was it all on-the-job training?
I took life drawing and painting classes in college, but then the call came to work in my dad's studio so I quit school and started working full time doing skateboard graphics for ads, T-shirts, stickers and decks. It was like being paid to go to graphic art school.

What is your medium of choice?
My favourite medium is pen and ink, just black and white, getting the lines super fluid and smooth. If you can make it look good in black and white then colour is a bonus. I also love drawing with pencil, painting with acrylics, drawing with Posca pens and spray-painting murals on walls.

Your dad's 'Screaming Hand' graphic is one of the world's most recognisable graphics. What is your most recognisable graphic and where did the idea come from?
I work in different areas like surfing, snowboards, music, clothing, decals, posters and toys, but my favourite is to design a skateboard graphic. That's where I got my start, and I still have a passion for it. I have many characters I use from time to time, like Pizza Face, Surf Freak, Skate Creep and Skate Squatch. I draw with pencil at night and come up with ideas, then later I will look at my sketches and decide which ones to take to the next phase.

You're a very talented skater and artist. If you could go pro, which one of the two would you pick?
I have been doing art professionally for over 30 years, and even though I am not rich, I have never questioned taking this route in life. It just feels natural to me and the personal rewards for me are beyond monetary value. Plus, it's really cool to see a kid at the skatepark riding your board or wearing your shirt.

How has skateboarding influenced your work as an artist?
I have been skating almost as long as I have been drawing. I got my first board in 1974, and have never been without a skateboard in my life. I will always ride, even if it means just rolling. Skating is such a release of energy. When I get home, I can relax and get into some drawing and think about the intense feelings that go through my head and relay them to paper.

Has your work on illustrations shaped how you skate or how you feel about it?
Being a part of skating is more than the act of riding. It is the way you look at the world: you see spots when you're driving around, it keeps you on your toes so you're always ready for what's coming around the corner, and when you slam and get back up and keep going it makes you tough and means you can handle a lot more in your day-to-day life. Skating also gives you common sense and allows you to see through the bullshit in the world.

What are some of the other skateboard-inspired artists that you follow?
My list is pretty old school, a lot of stuff my dad turned me onto like Rick Griffin, Big Daddy Roth, Robert Williams, Mouse, R. Crumb, Frazetta, Dali, Harvey Kurtzman and Mad magazine, as well as punk rock and heavy metal album covers.

Can you pick one and tell us what inspires you about this particular artist?
I'm an 80s kid so I've always admired VCJ, who did all the classic artwork for Powell Peralta. I remember when I was in junior high and first saw the Ray Bones deck with the skull and sword. It definitely burned into my mind. I've been drawing skulls ever since.

Are there any board companies grabbing your attention with their graphics?
Santa Cruz has always been my favourite skateboard company, of course, but I also like to do some graphics for Beer City, Plan B, Palace, Wasted, etc. Props to all the board companies out there keeping skateboarding alive!

Here comes another Phillips as your son Colby is following in the family's tradition. Any advice you have given him that you also heard from your dad?
My son is an apprentice at a tattoo studio, so he has been honing his skills and also loves to do graphic designs, so I always try to pass on the tips and tricks my dad taught me. Creating art for a living can be very challenging with long hours, creative blanks and sometimes not the pay you were hoping for, but it has many rewards that are self-gratifying.

What is the most valuable advice that you got from your father and passed on to your son Colby?
My dad taught me about sketching and I passed it on to my son. You can start with a completely neanderthal thumbnail sketch, but as long as you see the potential in it, you can trace over your sketch and redraw it better, and you can keep doing this until you build it up to a stunning piece. Then when you ink it you can really add the final touches to it and make the lines sing.

Last question. If you could interview any person in the world, who would it be?
Leonardo da Vinci or Jimi Hendrix, do I need to explain? •

13

Nekomata Skate N.2

Live now

Jonatan Hiroki Bando

After travelling around the world, Jonatan found his destiny in Whistler, Canada, where he draws skateboard illustrations with an oriental touch, representing his own diverse cultural background.

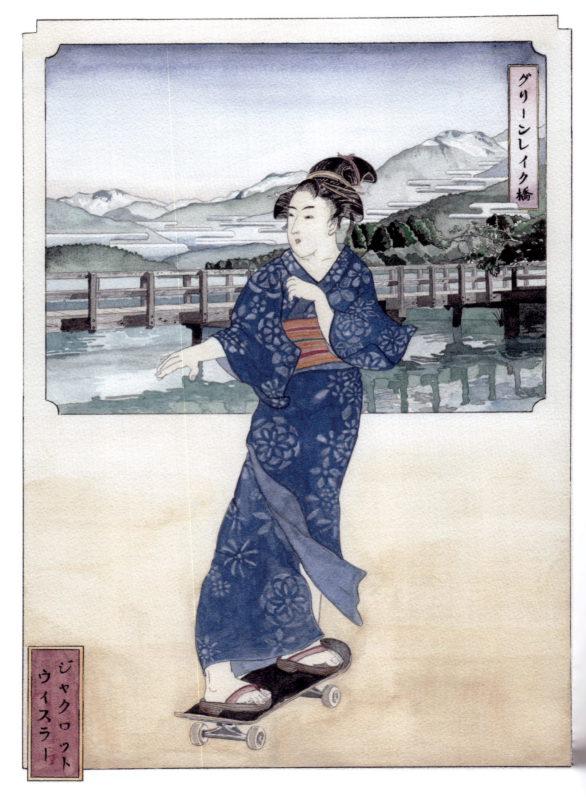

142 Bijinga N.1

< 'Bijinga is "Beautiful Woman Paint". In this artwork I tried to express the beauty of girl skater with a beautiful landscape on the back.'

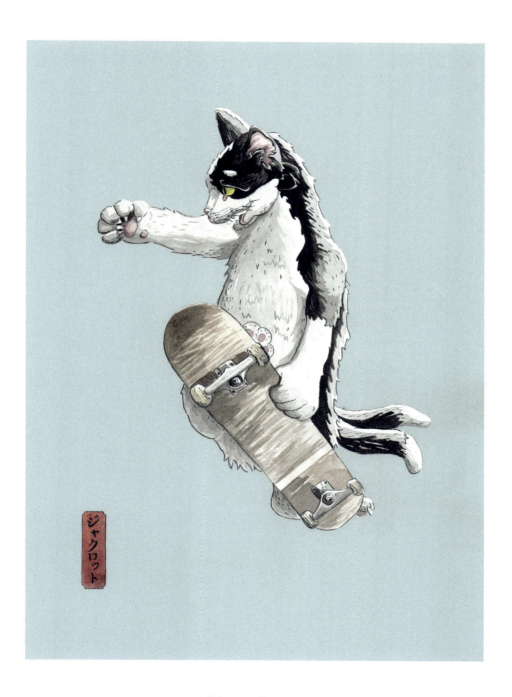

Nekomata Skate N.4

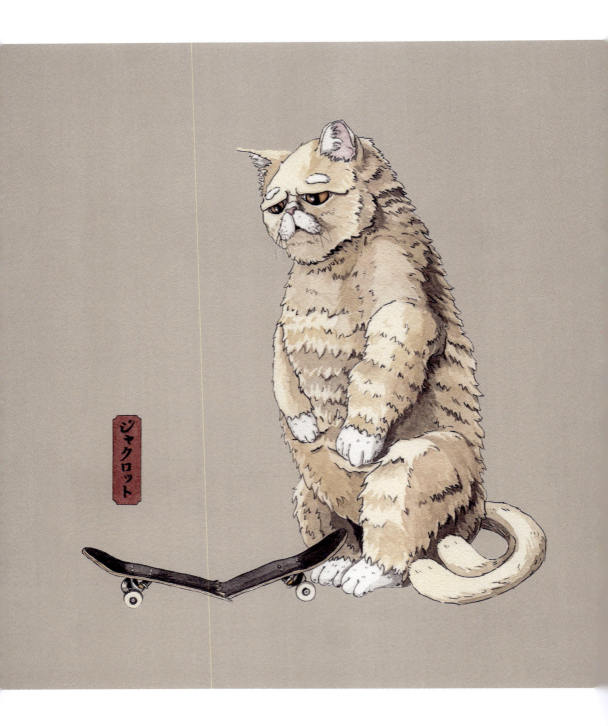

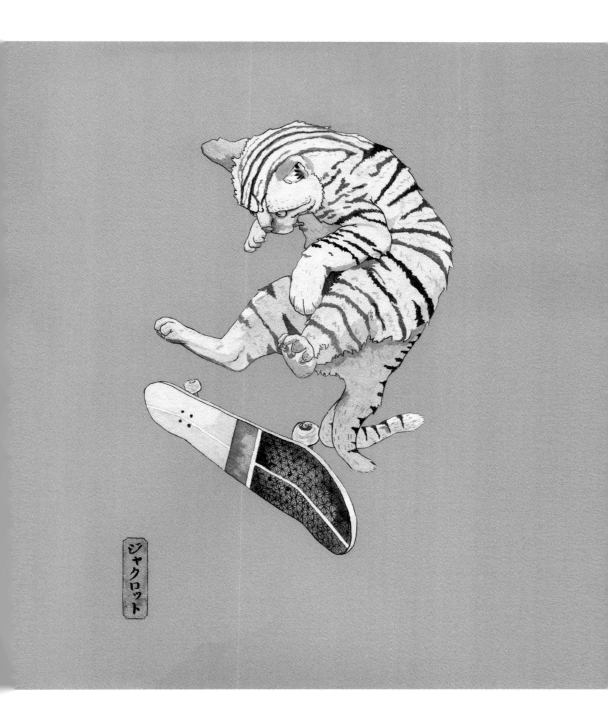

Nekomata Skate N.5

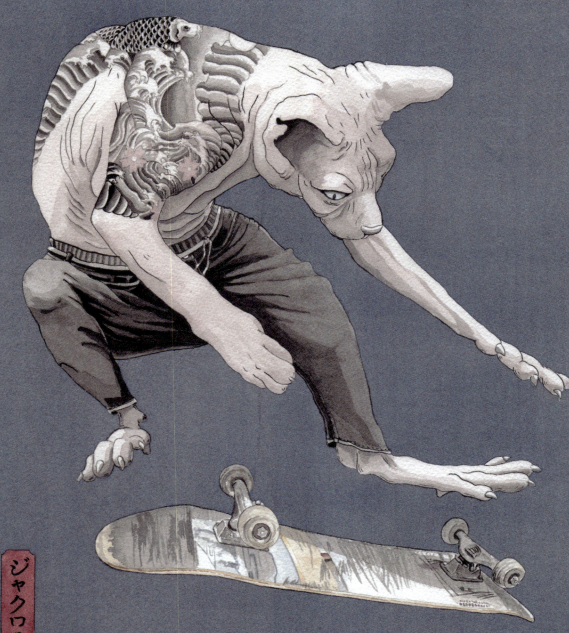

'Since I started skateboarding, I have felt a strong sense of connection and support among skaters.'

Q & A

Jonatan Hiroki Bando

Whistler, Canada

You travelled the world and ended up in Whistler, Canada, which you call your home. What do you like about this place?
The climate and Canada's great outdoors are surely appealing, but one of the main reasons Whistler is such a great place to live is the harmonious blending and coexistence of diverse races and cultures. The opportunity to work with people I like and do the job I love also seems very attractive.

How did you get into drawing?
I have loved drawing since I was little, but it all started when I saw a friend creating abstract art and realised that this way of painting was also possible. So, I used to paint a lot of abstract art in the past.

What is your medium of choice?
I mainly use watercolours now. When I moved to Whistler, I was living in a small, shared room, so watercolour was my only option.

How would you explain your style?
It's like keeping a diary. I create art to express what I've felt in my life and the messages I want to share with others.

Your work is influenced by skateboarding. What is the connection?
It all started with my desire to express the beauty of skateboarding. The process of perfecting a trick, along with each skater's unique dedication and style, has a lot in common with art, and I found many similarities between the two.

How has skateboarding influenced your work as an artist?
Since I started skateboarding, I have felt a strong sense of connection and support among skaters. I also learned valuable life lessons about perseverance and the happiness that comes from overcoming fear. I want to convey the many things I have learned from skateboarding to others through my art.

How did you get into skateboarding?
I started snowboarding first and began skateboarding during the summer to practise snowboarding. However, before I knew it, I found skateboarding to be even more enjoyable.

Your work also has a very oriental touch. Is there some personal background story to this?
I lived in Argentina until I was 11 years old, after which I moved to Japan. For a long time, I struggled to understand my identity. However, after a long journey, I realised that my existence is unique to me. I believe that my diverse cultural background and perspectives allow me to create something unique. My current style is a blend of all the experiences and influences throughout my life.

What has been your proudest moment?
The moment I decided to become an artist and live off my paintings. After a long journey, I returned to Japan and worked while thinking about what I wanted to do in the future. One day, just as I was about to get on my bicycle to go to work, it suddenly hit me: I want to become an artist!

Have you had any embarrassing or funny moments along the way?
When I was living in Australia, selling my paintings on the street, I ran out of money and had to borrow money from my parents for a plane ticket home.

Are there any other skateboard-inspired artists who influence you?
I often get inspiration from various skaters, but I might not get as much inspiration from artists. 'An egg cannot produce another egg.' I just don't know many skateboard-inspired artists.

What does your dream assignment look like in terms of brand and scope of work?
That's a difficult question. The thing is, what I'm doing right now feels like an extension of play, and I never intended to approach it as a job. So, my brand and my career as an artist might not grow as much as they could. However, since I'm able to earn enough to get by, I don't feel pressured. Of course, there are many small tasks that I don't enjoy but need to do for the things I want to achieve, but it's most important to enjoy what I'm doing.

Your theme is 'Enjoy the fear' when doing something new or risky. What is next on your list?
'Live Now' is another theme. It means putting your all into what is right in front of you. Whether you work just for the sake of earning money or dedicate yourself to personal growth, it can impact your future. Even if your current job isn't something you're passionate about, it may still be beneficial in unexpected ways in the future.

Last question. If you could interview any person in the world, who would it be?
The head of NASA. I would love to know everything they know about the existence of extraterrestrials and UFOs. Alternatively, I'd be interested in asking the leader of the Illuminati about the truth behind conspiracy theories. •

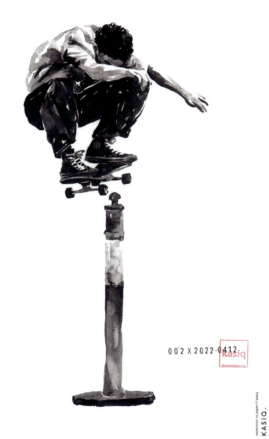

Slower pace

Kasiq Jungwoo

An illustration artist specialising in fashion, Kasiq Jungwoo has worked for numerous commercial and media projects through his favourite medium of watercolours, providing purity and depth. Combined with skateboarding, those single-frame, one-dimensional masterpieces truly come alive.

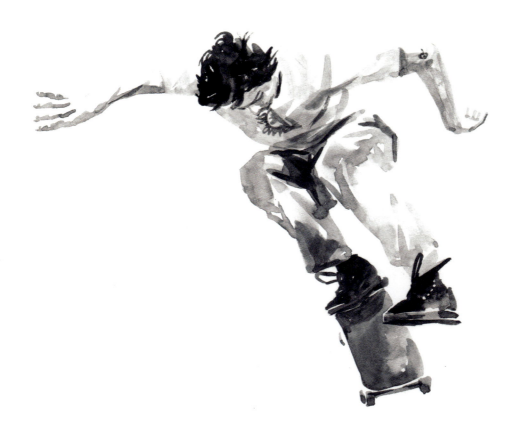

'I like the aspect of quick colouring after a long time planning it in my head.'

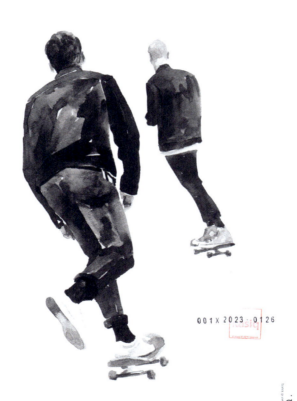

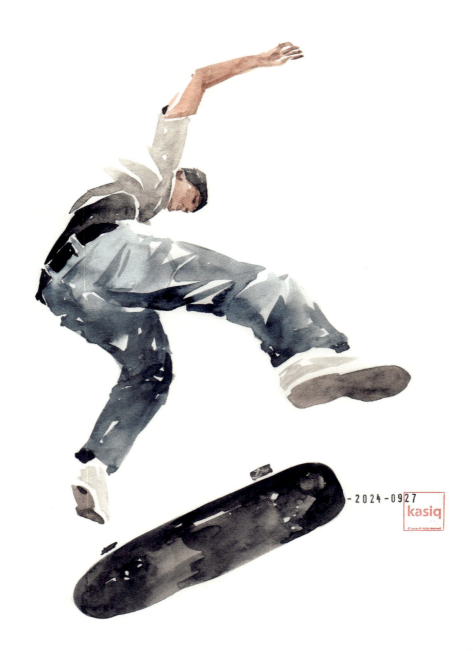

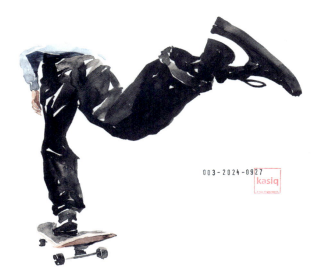

'I often watch skateboard videos on YouTube. I like to check out the tricks but also the skater's persistence and courage to fall and get back on their feet to try it all over again. The *Rat Ratz* channel in particular motivates me to further explore skateboarding.'

Q & A

Kasiq Jungwoo

Seoul, South Korea

What is it like being an artist in South Korea?
I feel like I'm going slowly without following the trend in a fast and competitive environment unique to Korea. I thought that if I lived this way, my life would also pass by quickly. This is why I want to live my life at a much slower pace.

How did you get into drawing?
I was one of the few children in class that could draw quite well. I learned that even adults liked my paintings. Painting, which I used to do as a hobby, like doodling in school, became a profession when I became an adult.

How would you describe the style of your artwork?
My work is light and shallow. In other words, it's clear and close. I think my work is close to the public. It's popular and familiar. Watercolour has clarity and depth. I like the aspect of quick colouring after a long time planning it in my head. I've been captivated by its charm for a long time. From simply wanting to draw a nice picture, the feeling of the brush touching the paper to the feeling of drawing became the only goal.

What is your medium of choice?
I create most of my paintings with watercolour brushes on drawing paper. Watercolours need to be completed before the paint dries, so I feel the sense of time in my paintings. I also use pencils and charcoal.

How did you discover skateboarding?
I've always loved the culture of skateboarding. When you look at their expressions, they look lively. I see excitement. I see them enjoying themselves.
When I was young, there was no skateboarding culture in my neighbourhood. There was just one old skateboard, but no one knew how to ride it. We just sat on it and rode down the hill.

Have you ever tried skateboarding yourself?
Skateboarding came naturally to me while raising two young children. Since then I've fallen in love with it. However, I should have practised sooner to teach the kids the moves.

What is it about skateboarding that inspires you?
Their movements look like flying birds. Even when they fail at what they want to do, they don't regret it and they try again and again. They repeat the same moves constantly. I respect that attitude.

What has been your proudest moment?
The time I spend painting watercolours is very short. On the contrary, sometimes I spend a long time appreciating my paintings. I'm proud to think that, just like me now, someone will have time to look at my paintings.

Have you had any embarrassing or funny moments along the way?
I once did the cover for one of singer Ed Sheeran's albums. I enjoyed his music, but didn't know his face. And I didn't know whose face I was drawing. I thought my client was just a very young but not yet famous artist. The album I worked on made it to the top of *Billboard*. I realised later that I had painted a picture for Ed Sheeran's album.

When did you decide to become a full-time artist?
The work I was doing previously was very boring. I enjoyed taking time out to pursue my hobbies, such as drawing. Every time I did that, I thought I wanted to live my whole life just painting, and that's what I've done.

Was there a specific moment when you turned into a full-time artist?
I've always been drawing, but one day I drew a particularly good picture. From that moment on, I was convinced that if I continue to draw pictures like this, other people would like it as much as I do. I felt surprisingly confident that day. But the strange thing is that, looking at this picture now, I don't feel it was a good one at all. However, I think I felt something in the process of drawing that gave me the confidence to pursue a career as an artist.

Any advice for people that want to go down the same path?
You should continue to draw pictures that you like. When you draw other people's favourite pictures, you sometimes forget what you like.

There are so many online platforms for artists to share and promote their work. Which works best for you?
I like Instagram. This is because I'm used to it. It's because there are many different people, not just people who paint.

Are there any skateboard-inspired artists that you follow?
I like the work of Ryan Hugh Allan and Quentin De Briey, who are both skateboard photographers. But I don't really follow any actual skateboard illustrators. Also, I don't try to find them as I want to draw my own style of paintings without copying them.

Is there a specific brand you would like to work with?
I would like to collaborate with Vans. It's a brand that I actually enjoy. It's cool and functional at the same time.

Last question. If you could interview any person in the world, who would it be?
She's not a celebrity, but I'd like to interview my aunt, who passed away a while ago. She always told me that I would become a successful artist. I wanted to tell her about my success, but it was too late, unfortunately. I want to talk about how happy I am as an artist and also hear from her when she was younger.
In terms of celebrities, I want to interview Haruki Murakami. Although he's a writer, I deeply respect his attitude and diligence as a creator. His writing style is neither boring nor provocative, even when read repeatedly. This is the direction I'm heading in. Also, whether he intended it or not, my impressions change each time I read it. I think it's the creation of an infinite world. I'd definitely like to have a conversation over a beer with him. •

15

The Forgotten Road 1, Inverness, Scotland

Collecting skate spots

Lorna Goldfinch

Lorna Goldfinch's sketchbooks are a visual diary of unique and everyday skate spots from around the world, bringing the different feel, vibe and mood of each spot to the surface.

'If you go to peg out the washing in the backyard of Michelle's stone cottage in a tiny village in Cornwall you will be met by a surprising concrete miniramp filling most of the space. A compulsion for making things, she also had a wooden miniramp in her screenprinting studio slash band rehearsal space.'

Backyard ramp, Cornwall, UK

After Death, Hjärup, Sweden

'The Bothy Bowl was the whole reason for my trip to Scotland. I was building a DIY quarter in Cornwall when the friend I was building with mentioned a Bothy Bowl up near Aberdeen that only a handful of people knew about. I just couldn't even imagine it and there were no pictures, I had to make the trip up to see if I could take a look.'

The Bothy Bowl, Aberdeen, Scotland

'There is still some kind of magic when opening a smallish book and every bit of the surface is covered in paint.'

Huia Miniramp, Auckland, New Zealand

Q & A

Lorna Goldfinch

Cornwall, UK - Malmö, Sweden - Auckland, New Zealand

You tell stories through your painting of skate spots. Is there a specific message you want to convey?
I think each spot has its own story to tell and I like to sit for a while and paint what I see and hope that some of what the place has to say comes through. I have a personal interest in the way that we can understand something of people by the places they create or use. I feel that is the one defining thread throughout my work, but I'm also interested in the passage of time and documenting these treasured places before they turn to rubble.

You started skating in the 90s. What got you into it?
I was kicking around in my hometown when I was 15 and a group of skateboarders were gathered on this old concrete bandstand, so I sat and watched for a while. They didn't ask me to leave, and I enjoyed the feeling of being around such a diverse collection of people. I was more of a loner, preferring my own company, but found a home within this ragtag bunch. As I got up to leave, they suggested I get a board for myself, which I did. I remember feeling encouraged and welcome, but never looked down on. I felt totally free to be myself.

What is your medium of choice?
I've used a lot of different mediums over the years. When my paintings were more structured, I enjoyed watercolour washes with ink linework. My current sketchbook work, which I've been doing for the last few years, is all in gouache on brightly primed paper. In my studio, I work in oil or gouache on wood panels.

How come you decided to paint your landscape images on a double page where you get this halfway mark across the image?
Interesting question. In part, I wouldn't be tempted to be too precious about them. The idea all along was that they are an unfolding story (no pun intended) as opposed to standalone pieces. Occasionally I've experimented with larger format sketchbooks and only painting on a single side, but it didn't hold the same feeling for me with the white paper of the other page visible and it's awkward to hold a book twisted around when hunched on the ground at a location. There is still some kind of magic when opening a smallish book and every bit of the surface is covered in paint – it becomes a portal that sucks you into a different world rather than an image you are viewing on a page. Also, whenever I worked on half pages or single sheets, I would almost always give the paintings away to people who felt a love for the place I had painted. In the sketchbook double pages, I can't

actually do that, so it forces me to keep them all collected together, which I am glad of now.

You travel between England, Sweden and New Zealand to paint. Do you also paint from photographs or do you need to be there in person?
For a few years, I was quite strict about working on location. I wouldn't even touch the paintings in my sketchbook again once I left a spot, but I have relaxed about that now. Sometimes I'm at a great backyard pool or something and have to choose between making a painting for three hours or getting to skate it, and if I'm only going to be there once, I'll skate it, and shoot some reference photos for my archive in case I can't get back there with my paints. I figure now that the whole experience is all still feeding into the final paintings.

If you could pick any skate spot in the world to draw, which would it be?
I'm currently a little in love with the backyard pools in the States and would love to do a series just focusing on those. They are skateable for such a short amount of time, they're like sparklers. I feel like documenting them would contain some of that magic, some of that joy and transience.

Have you had any embarrassing or funny moments?
Most of my painting missions are solo and I do my share of hiding from security guards or other people when I'm trying to find the spots in the first place. Once the paints come out, I'm pretty much locked in and the rest of the world fades out. Sometimes I blink back to reality at the end of painting to realise I'm surrounded by rabbits and magpies, Disney princess-style.

In an interview, you mentioned that it's healthy to be a beginner at things, to let go of your ego and expectations. What is the next thing you want to be a beginner in?
Right now, I'm a beginner at a couple of things, and I absolutely love it. I go BMX jumping with some friends on Saturday mornings, and I surf really, really badly when I live in Cornwall and Auckland. It's so freeing and healthy for me to be terrible at things in public and to have to dissolve the part of me that would feel self-conscious. I enjoy how absurd being a human being in the world can be, how fragile we can feel around people seeing us making mistakes and how important it is to just let go of all of that. I think that kind of mentality can be contagious too. If you're not embarrassed to be terrible at things and still find joy in trying them, then it gives the people around you a lot of freedom to be imperfect too.

Last question. If you could interview any person in the world, who would it be?
I would love to sit down with Ozzie Ausband behind Blue Tile Obsession, a blog all about pool skating in California. There are a few people you hear about who carry such dedication and passion for their niche corner of the world and Ozzie is one of those that seems to bring everyone together. It seems like he's a keystone of sorts for that entire world. He's literally brimming with stories and enthusiasm and an obsession for documenting moments before they've passed. •

Kenny Reed

The French dreamer

Lucas Beaufort

Lucas is a self-proclaimed 'French Dreamer' who was called upon by a beautiful monster to start drawing. When he did so in his mid-20s, the terrible nightmares he grew up with suddenly stopped, and the rest is history. He's still making history every single day. All around the world.

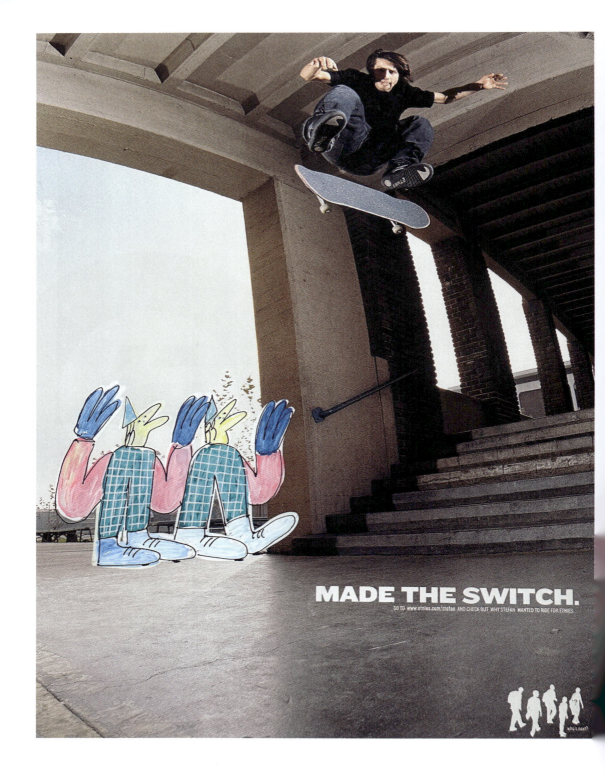

Stefan Janoski

'If I have no more dreams, it's like dying slowly.'

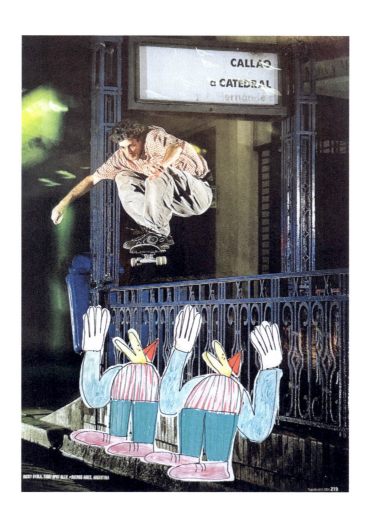

Ricky Oyola

'At 13, I went into a real skate shop to buy my first board and the magic began.'

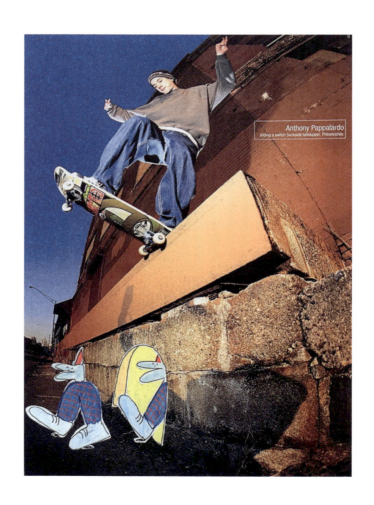

Peter Smolik

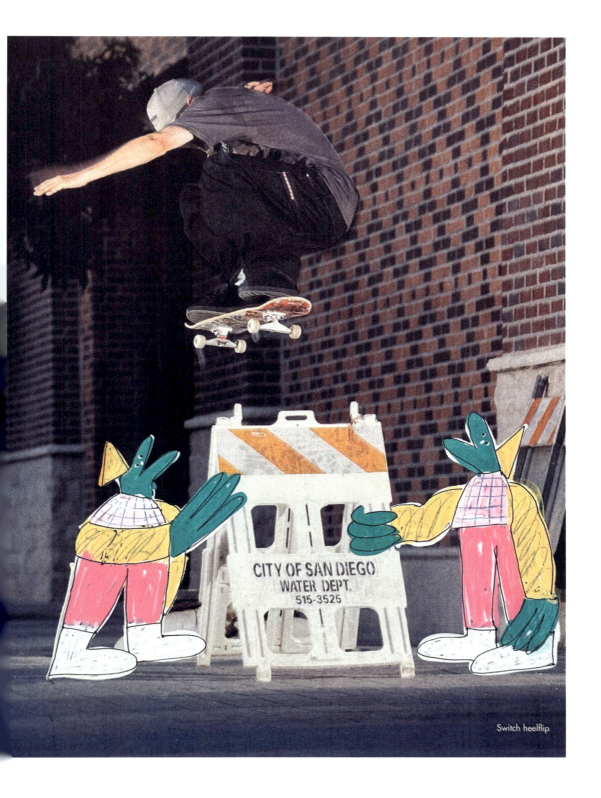

Switch heelflip

Anthony Pappalardo

Q & A

Lucas Beaufort

Cannes, France

You're a painter, illustrator, filmmaker, photographer and author. Is there one you are most passionate about?
It's hard to say, as all those activities are linked. One comes with the other. Travelling is also part of my lifestyle and meeting new people is my favourite thing. What would life be without others?

In an interview you stated 'I am a French Dreamer living surrounded by beautiful monsters.' What do you mean by that?
I grew up with terrible nightmares. The day I started painting (27 years old) all my nightmares suddenly stopped. I have the impression that there was a character deep inside me who urged me to paint.

You only started painting at the age of 27 when you drew something for your brother. Did he encourage you to explore this further?
Honestly, no one could have imagined the way things would turn out. My brother received the very first artwork, but didn't really push me to continue. He was as surprised as everyone else, but I'd say it was more my parents-in-law who pushed me by asking me to do a painting for them right after. It was like a snowball.

Apparently, it took you five years to make a living from it. Can you take us through the moment when you decided to go all in?
That's right! I started painting in December 2008 and quit my job to try my luck in 2013. It was a huge risk, but I couldn't pass it up. To be able to do what you want as your own boss is an incredible freedom. At the time, I was working on a crossover magazine called DESILLUSION. We went from nothing, a little 15-page fanzine, to a publication respected by everyone and distributed worldwide. I wanted to turn the page because I felt we couldn't go any further.

Your art is heavily influenced by street art and skateboarding. How did you get involved in skateboarding?
It all started with skateboarding, I'd say. I started at a very young age, like six, but it wasn't serious, just a plastic toy, and my mother got fed up with me putting holes in my clothes and confiscated my board. At 13, I went into a real skate shop to buy my first board and the magic began.

Is this why you published a book about skate shops called *Heart*?
Probably! It's mainly because my life was inspired by skateboarding and I put all my love into it.

Some of your illustrations are applied to skate shots. Where does the idea come from?
Simply because I love picturing myself at that place, at that moment. My monsters are my eyes, and I imagine myself witnessing the moment.

What has been your proudest moment?
When I created my Montreal mural, the largest to date.

You're really into murals, but afraid of heights. Have you ever had to decline an opportunity because of that?
I'm really afraid of heights, but I'll always overcome this fear in favour of creation.

What have been your most embarrassing or funniest moments?
Funniest moments? I can't pick one – my life is an adventure filled with funny moments.

What is your seemingly unlimited resource for inspiration and creativity?
I find inspiration in my travels. The more I travel, the more I nourish my desire for new experiences.

Your medium of choice is acrylic paint and brushes. Are there any techniques you want to learn/master in the future?
It's true, acrylic paint and brushes are my favourite tools. I'm in the process of building a real studio and will be able to explore mosaics and sculpture.

Are there any other skateboard-inspired artists that influence you?
Without a doubt, Geoff McFetridge. I really love his perspectives and angle. When I see his work, I'm always blown away as I would have never thought to use this angle.

Which board company do you like most in terms of their graphics?
Right now, Quasi and Pass-Port. I love their visions, I love their graphics. To me, those brands are so personal, so unique in an over-saturated market. It's really difficult but they make it happen their way.

In an interview, you said 'I chase all my dreams and crazy ideas as an epicurean who wants to try everything.' Is there anything on your list you have not tried yet?
Of course, and it's also my driving force in life. If I have no more dreams, it's like dying slowly. I'd love to sail around the world.

Last question. If you could interview any person in the world, who would it be?
I would say Thom Yorke. If I had to keep one band on this planet, it would be Radiohead. I think Radiohead can change the world. •

17

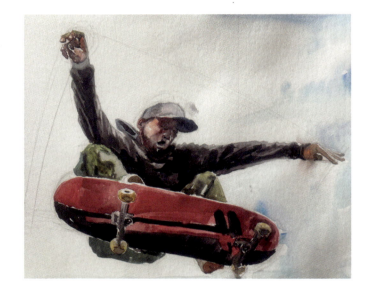

Statistic

Getting up

Matt Harward

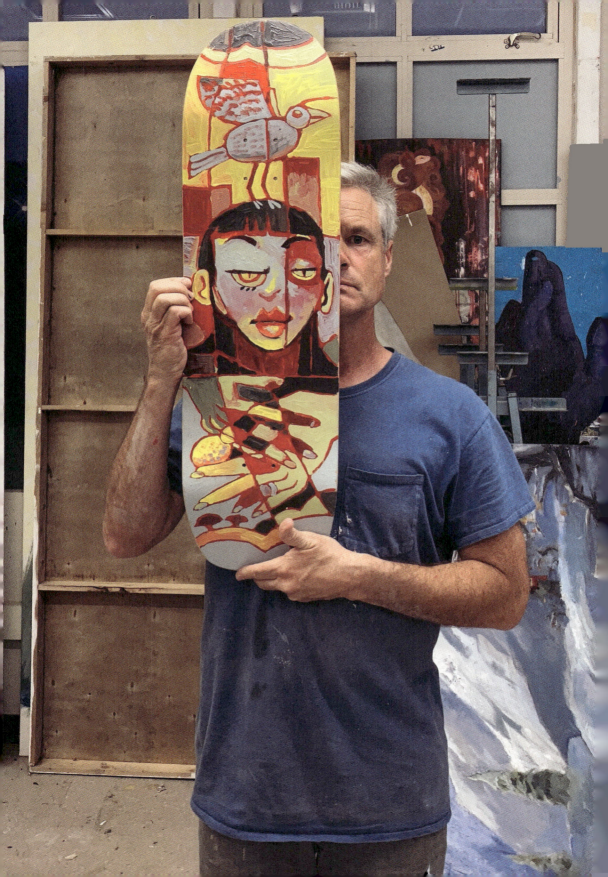

Matt is not just an art teacher, but also a full-blooded artist that lives, breathes and creates art every single day. He has also been a skateboarder for over 40 years, creating acrylic illustrations of iconic skaters by mixing both passions.

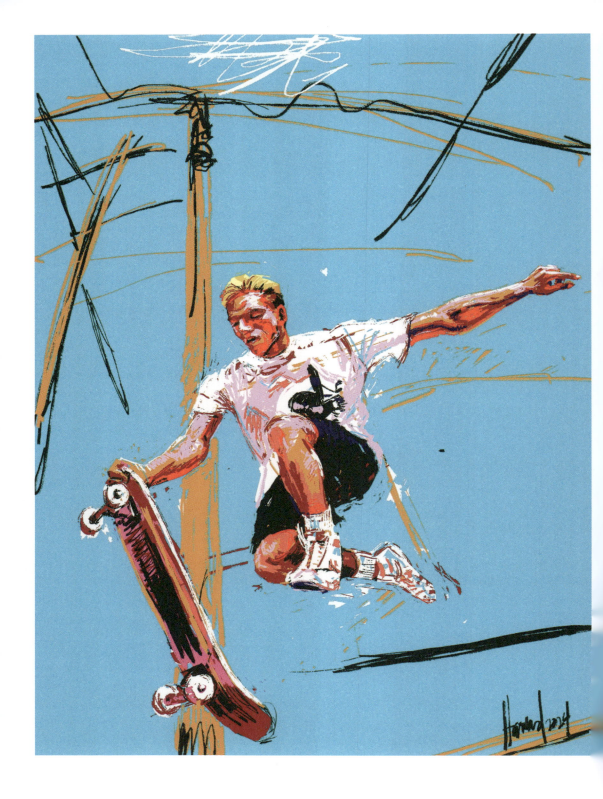

'Skateboarding created
a freedom
and bonds
of friendship
and support.'

'I believe drawing is the foundation for anything creative.'

'This is my friend Ed Templeton. We hung out a lot from 1988 to I'd say 1992. We would art out together and skate together. Painting him is a tribute to him and our friendship. I miss Ed. I've been so busy with my family for the past 30 years. It felt good to create this painting. I want to create a watercolour of him.'

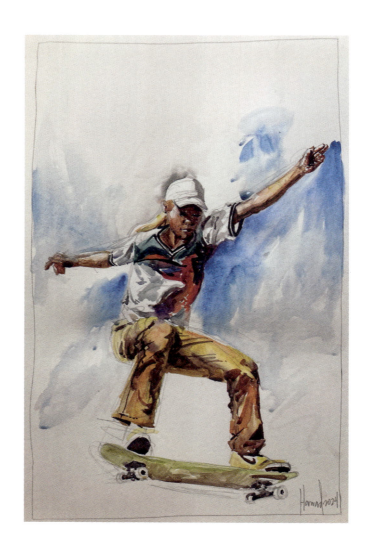

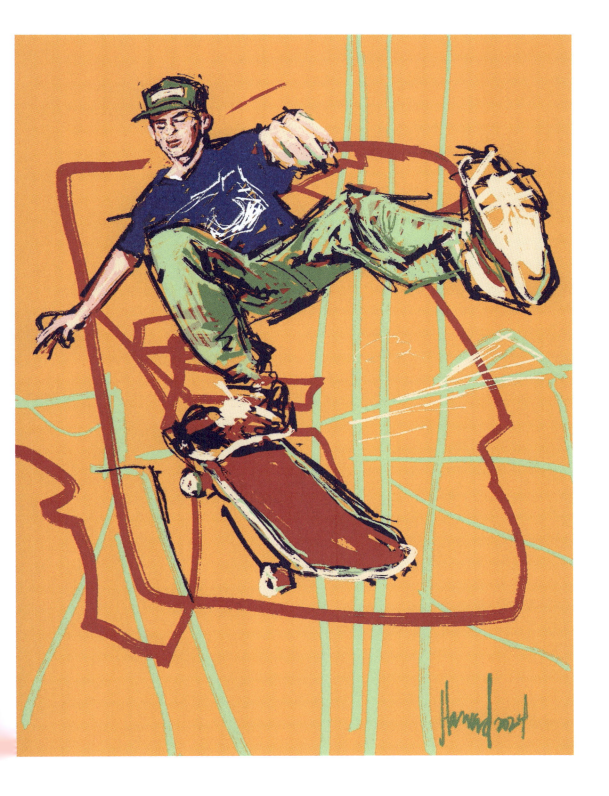

My bro

Q&A

Matt Harward

Huntingon Beach, US

Drawings, paintings, murals, illustrations, designs, pottery, sculpture. Is there anything you cannot do?
Yes. Digital 3D modelling, home construction and fixing cars. I'm working on that.

What is it that you like doing most?
Drawing – I can do it anytime and anywhere. I believe drawing is the foundation for anything creative. If you can explain something with a picture or create the vision for a client or your own vision, the art can get done – whatever it is.

What is your medium of choice?
My mediums of choice are pencil and paper and acrylic paint because it can go on anything and dries FAST! Digital is rad because of the changes/adjustments you can make to an image.

You have a background in skateboarding, which isn't really a surprise given that you're a Huntington Beach local. What came first, though?
Art came first – my brother and I grew up creating. We were playing in the mud, digging tunnels, running the hose in the tunnels, taking our trucks, cars and action figures outside and getting crazy out there. I think that was around age 8 to 12. My brother and I always drew and continued drawing in middle and high school. I was born in 1972 and so the 80s were super influential. I remember going over to my next-door neighbour's house and seeing the animated movie *Heavy Metal* on his TV! It was crazy and mind-blowing. My neighbour, Steve Tanasse, had a huge comic book collection as well. I would just look at all the pictures, not read them, and that was super influential. Also Dungeons and Dragons was a board game and I remember being into the art and getting lead figures and watching the animated version of *Lord of the Rings* as a kid. I was exposed to art and super creative stuff early on, as a kid. My dad took me to see it. My dad also drew. Not a lot, but he was super good at it! He was an electrical engineer but man, could he draw. He definitely influenced me as far as art is concerned. I miss him. He died when I was 20.

How did you get into skateboarding?
My friend Brandon Kent (BK) from church got me into skateboarding in 1984, I'd say. One day he asked if I wanted to watch a skateboard demo at Gremic Skateshop in Huntington Beach, CA. There was a halfpipe and all these pros showed up. I was mesmerised. After a bunch of kids got on boards, they hopped a wall into a kid's yard and there was a mini ramp back there. I didn't even skate. I just watched. I was hooked after that.

How has skateboarding influenced your work as an artist?
I'm not sure, but I know it has. The weirdness. Punk rock music. The skulls, mohawks, crazy graphics, jack-in-the-box, anything goes vibe. There is no 'right' answer. Every new graphic was an influence. Every new band was an influence. Every new skater, etc.

Has your work on illustrations also shaped how you skate or how you feel about it?
I wouldn't say my illustrations and art shaped how I skate. The mentality of skateboarding shaped how I skated. There were endless possibilities to tricks and life in general. Skateboarding created a freedom and bonds of friendship and support and all answers are right and my answers to life are right and good. My friends and the culture shaped how I skate. I mostly roll around these days. I create art daily.

You're an art teacher. How difficult is it to balance your students' creativity and inspiration while teaching basic rules and concepts?
Easy. It's only taken me 20 years to get a handle on it. What I want to teach them is usually what they want to learn. I teach the fundamentals, and I've also found a way to work with their styles and make their work stronger. I also remember being inspired by my art teacher's demonstrations, so I try and do the same.

In an interview, you mentioned that God and art have helped you to cope with hard times throughout your life. You've used it to let out negative feelings and grief. Have you ever thought about turning this personal experience into a kind of art therapy to help others in similar situations?
I haven't thought about that and it's a great idea! Creating, in any area of life, is a great way of getting through life's challenges and celebrating the beautiful, positive times. Every day is positive. We need to choose to see it as such.

Are there any other skateboard-inspired artists that influence you?
I don't really know of any skateboard-inspired artists now. Wait, my buddy Jose Cerda. Back in 1984, there was Chris Miller, Neil Blender, Pushead (did the Zorlac boards), the guy that did the Powell graphics. My friend Ed Templeton and I used to art out together (I met Ed around 1988). There was also Jinx (Marty Jimenez) and Andy Howell.

That makes complete sense and I'm star-struck. Do you still keep in touch with these guys?
I was friends with Jose Cerda and Ed Templeton, so I keep in touch with them and they are super cool guys. I admire them for pushing through in the skateboard industry and making it their careers. I didn't know the other guys, but they were definitely influential. They were, in my opinion, a huge influence on skateboarding and the art of skateboarding. Ed definitely was and is. Marty is a rad guy and I created some graphics for his company, Channel One, back in the day. I need to contact Marty and say hello.

Last question. If you could interview any person in the world, who would it be?
I know this isn't the normal answer, but I like to interview people I meet or new people. I like to re-interview people I know and don't know. The interviews are short and sometimes I just listen. •

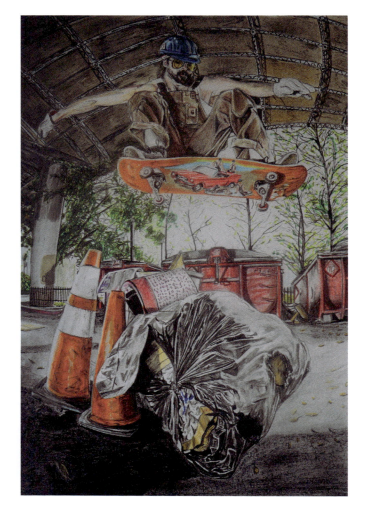

Manramp

Graphite detail

Max Schotanus

An art exhibition about Swedish board company Polar was the trigger for Max to take up skateboarding and use their creative direction to make his own very detailed graphite drawings.

inktr.ee/MaxxisArt ~~~ @maxxis.art

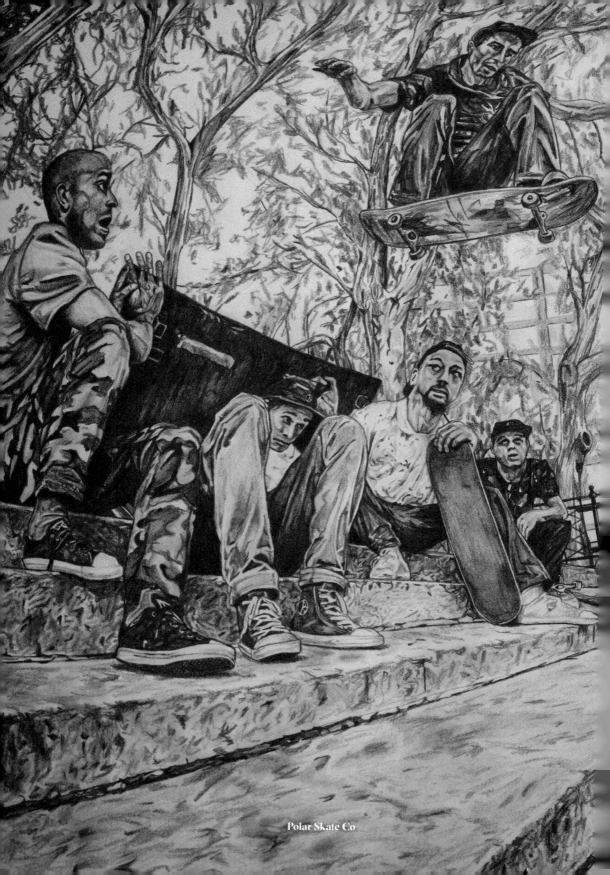

Wallride

'I try to make my art work as detailed as possible so there is a lot to look at.'

Pontus Alv

Q & A

Max Schotanus

Jubbega, the Netherlands

What came first: drawing or skateboarding?
Drawing, for sure: always have, always will! Drawing and making art in general has a heavy influence on my daily life. I always search for new inspiration by looking at art, photos or creations from others. Skateboarding came along for me around the age of 15 or 16. First skating, later longboarding, because I wanted to skate longer distances. I was never really a person that could do tricks anyway (laughs). Skating gives me a certain sense of freedom. I'm sure fellow skaters know the feeling! When I found my way around realistic graphite drawings, I started to draw skaters I really liked at that time. Currently, I longboard less since I bought a car that takes me everywhere nowadays. The board is always in the back though and I do take it for a spin every now and then.

What is your medium of choice?
Mainly traditional dry media, such as colour pencils, graphite and markers on paper.

Your pencil drawings are super detailed. How many hours does it take you on average to complete one and how do you manage to not get it all smeared?
Thank you! Yes, they are detailed. I try to make them as detailed as possible so there is a lot to look at. The time it takes to complete a piece really depends on the size, of course, and the medium used. Like the large graphite piece called *Polar Skate Co*. took around 25 to 30 hours, I guess. The smaller ones around 4 to 8. I don't really keep track of how long exactly. It also takes quite a long time to actually complete something because I don't draw for hours on end. In terms of the smeared part, my hands do get all grey because of the blending and the table gets messy with bits of the eraser. It doesn't affect the drawing that much, as I taught myself a method to first make a thin sketch of the whole thing and after that fill it in from left to right. This way I don't get my hand on a 'completed' section of a drawing.

How does skateboarding influence your work?
The moment I got really interested in skate culture was when I visited a photo exhibition about skateboarding. The exhibition was called *Absolute Event Horizon II* and was presented at Schunck Glaspaleisin Heerlen back in 2017. I was 16 at the time. It was all about Polar Skate Co. and mastermind Pontus Alv. The DIY

culture and the way the photos of the group were taken (along with loads of doodles from Jacob Ovgren) inspired me to illustrate and dive into this specific group. I made three graphite drawings of photos that were taken by Nils Svensson. Two of them were taken in Polar Skate Co. films. Another film I bought was *I like it here inside my mind, don't wake me this time* and definitely recommend watching it!

I got inspired by Jacob Ovgren's funny drawings and doodles for the group and decided to pick designs by him to paint on my own decks. Quotes from the group that always stuck with me are 'If everything is possible in our dreams, why can't we sleep forever?' and 'Inspire others to inspire themselves'.

What has been your proudest moment?

I guess relating to skate art, being recognised by my favourite skaters on social media (Instagram). Being able to create art, like commissions and such, for others is really special to do and something I'm really proud of. It's about the idea that my art goes places and gets a spot on someone else's wall.

Who is your favourite skater?

I'll have to go for Pontus Alv, since he inspired me a lot with his creativity.

Are there any skateboard-inspired artists you follow?

Rob Benigno, who is an artist. This man's creativity literally knows no bounds — he creates a lot of different things! Like graphics, stickers, giant street-art murals, graphite drawings, pencil sketches. The subjects of each piece also vary a lot, from realism to cartoon-style designs. If I look at my own work, there are differences in subjects but not so much in style or medium used. It's cool to follow someone who can do it all like Rob Benigno!

Jacob Ovgren's work has a comic look to it. He uses bright solid colours and black linework, which make the designs really pop. His drawings always have a goofy look to them — combining cute and silly things with dirty-minded stuff is his speciality and he creates some controversial pieces by doing so. I love the way his drawings are combined with Polar photos in collage style.

What else is on your wish list?

It feels like I achieved a lot already honestly, so I'll see what the future brings! One of the things I wish to do is participate in a local art festival or create a solo art exhibition to show my art and receive reactions from others.

Last question. If you could interview any person in the world, who would it be?

That's a tough question! I guess it would be some of my favourite artists I follow on Instagram just to get to know them. And to get to know more about their source of inspiration and perspective on art. I'm mainly into portraits and surrealism at this moment. So, I would choose Jennifer Allnutt — her work is stunning! She mainly portrays female faces combined with flowers and a touch of darkness. The style is balanced between realism and illusionism. This combination is hauntingly beautiful, if you ask me. Her work inspired me to create surreal portraits, which can be found on my Instagram. I really wonder what the story behind some of her works are, as they seem to portray a personal story at times. •

11
12
13
14
15
16
17
18

19

20

Kickflip

Bold and free

Natalia Ablekova

Natalia's skate illustrations are such a stark contrast to her usual black and white comics with ink and pen. Simple. Minimal details. Bold colours. Digital.

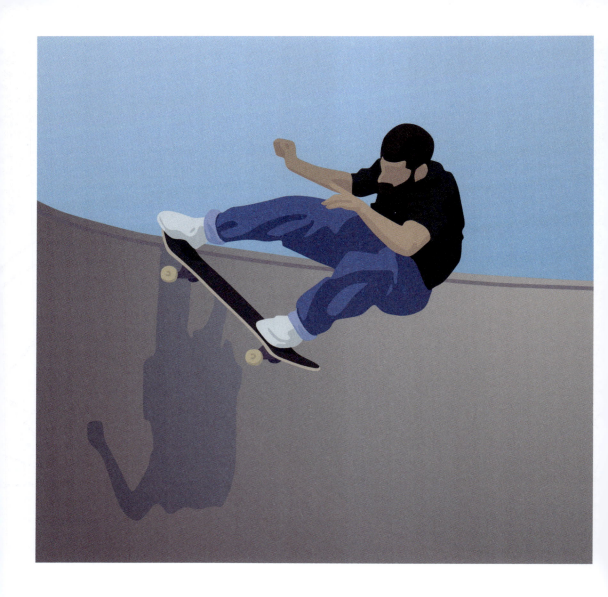

'I like this moment at the top of the ramp before you go down heart is beating faster. I tried to convey this feeling in my drawing.'

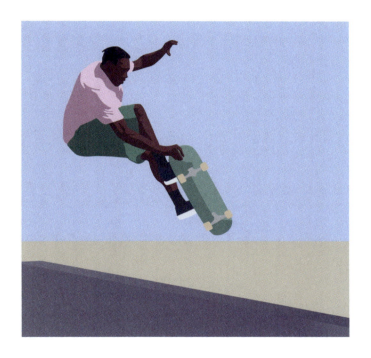

'This illustration is based on a short video. I removed all unnecessary details and edited the composition so that the person was above the horizon.'

Short flight

'I think
skateboarding
is a form
of freedom.'

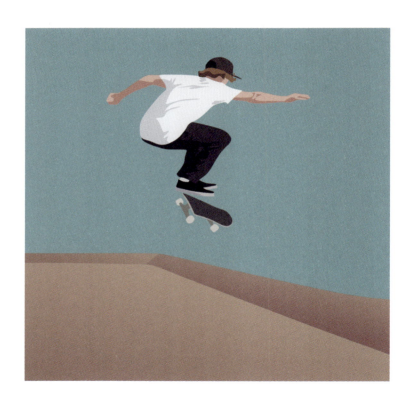

Rump jump

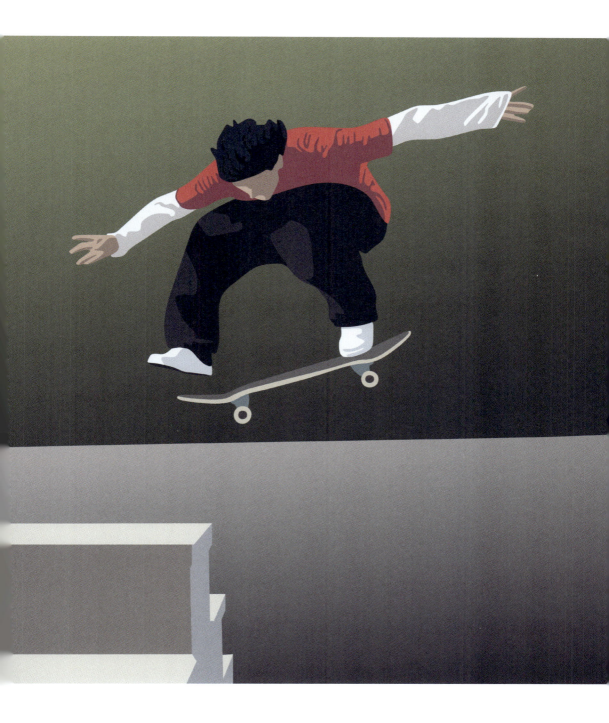

'This illustration is also inspired by a short video. I like the silhouette of the skater here, and I used contrast colours red and green for more impression.'

In the air

Q & A

Natalia Ablekova

Moscow, Russia

You are a comics creator, artist and graphic designer. What do you like doing most?
I really like doing comics, creating stories and then drawing them. I also like drawing paintings as an artist. Sometimes I work as a graphic designer too. I like to read mystical fantasy stories, for example *The Sandman* by Neil Gaiman, one of my favourite comics. I like this comic because it's a very complicated story. I've re-read it many times and each time I've found new meanings in it. Also I really like Japanese manga, the most famous one being *One Piece* about a pirate adventure at sea. *One Piece* is also a really long story that is still going. I've been reading it for many years and every week waiting for a new chapter.

How did you get into drawing?
I decided to become an artist when I was 13, because I just liked drawing. I started preparing for art college. In 2017, I graduated from the Moscow State Academic Art College in Memory of 1905 and after that I worked as an artist in different art media. I was also an art teacher.

What kind of comics do you create?
I like to create science fiction and fantasy comics. Most of my comics are black and white. I draw with ink and pen, which is the old fashioned way of creating comics. Lately, I've been drawing more in digital formats.

You include skateboarding in some of your illustrations. Is there a special connection?
I've been skateboarding since my teenage years. I like to skateboard in parks and along the river. For me, skateboarding is a good way to clear my mind and forget about my worries.

How did you get involved in skateboarding?
There's no big story behind it. I was 11 or 12 years old and I think I asked my parents for a skateboard for my birthday. I remember that we went to the shop together to choose my first board. I was very happy when I received the gift. And after that I started skating with my friends from school. Some of them also had skateboards and others had roller skates. We had a good time in the summer.

What is it about skateboarding that inspires you?
I think skateboarding is a form of freedom. I'm not good at kickflips. Watching skate clips or skaters in the park doing tricks inspires me to draw some of these beautiful tricks.

What has been your proudest moment?
It's hard to pick one moment. I'm proud of my art college diploma project. It was a stage design project for the play *Caligula* by Albert Camus. After college, I took part in several exhibitions. One was called *Lampa*, which was also an art market in ArtPlay, Moscow.

Have you had any embarrassing or funny moments?
I think almost all artists have a story about a customer who didn't know what they wanted. I had a customer who was looking for illustrations for a book. I asked them if they wanted to see some references but they just said that they trusted my artistic taste. But then they didn't like what I did. I refused the project and proposed another artist. They somehow made it happen.

There are so many online platforms for artists to share and promote their work. Which works best for you?
I don't know which platform is best. Instagram is a good platform, but my account is still small. Mangalib is a good site for comics. I think I need to translate my comics into English and publish my stories for English speakers, to find more readers and followers. Behance is a good platform because you found my work there. When I published my skateboard illustration on that platform, I definitely didn't expect that someone from Australia would find my artworks and get in touch with me for a book project. That was unexpected and very pleasant.

Is there any skateboard company that you follow based on their graphics?
I'm following the Russian skateboard company Footwork Skate. I like the designs of their boards and they have some cheap boards too. I'm also following a few local skateboarding shops like Skvot and Oktyabr.

What does your dream assignment look like in terms of brand and scope?
At the moment, I'm thinking about comic books. My dream would be to write a big comic book with multiple volumes and work with a major publisher. I'm currently working on a script for a comic book about vampire hunters. It will be a dark fantasy story with mystical elements. The main character is a vampire hunter, but at the beginning of the story she becomes a vampire. And after that she needs to join the vampire society. I'm planning to add intrigue to the plot. For example, why did the main character become a vampire in the first place? There will be vampire villains and good guys. I can't tell you too much yet.

Last question. If you could interview any person in the world, who would it be?
Actually, there are a lot of artists who come to mind. Artists mainly from the Renaissance and 19th century. For example, I want to interview Leonardo da Vinci. I could read his books, which form some sort of conversation, I guess. One person I'd really like to talk to is my grandfather, who died before I was born. He was a Soviet physicist. From family stories, I know he was an interesting and educated man. I feel sad that he died before I got to meet him. •

11
12
13
14
15
16
17
18
19

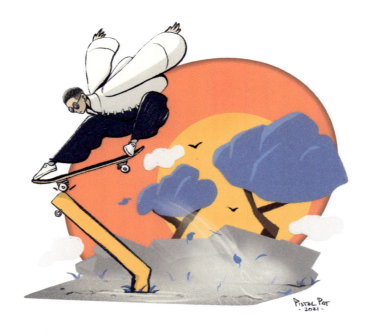

20

Martrix

Kooky but fun

Pat De Vera Sison

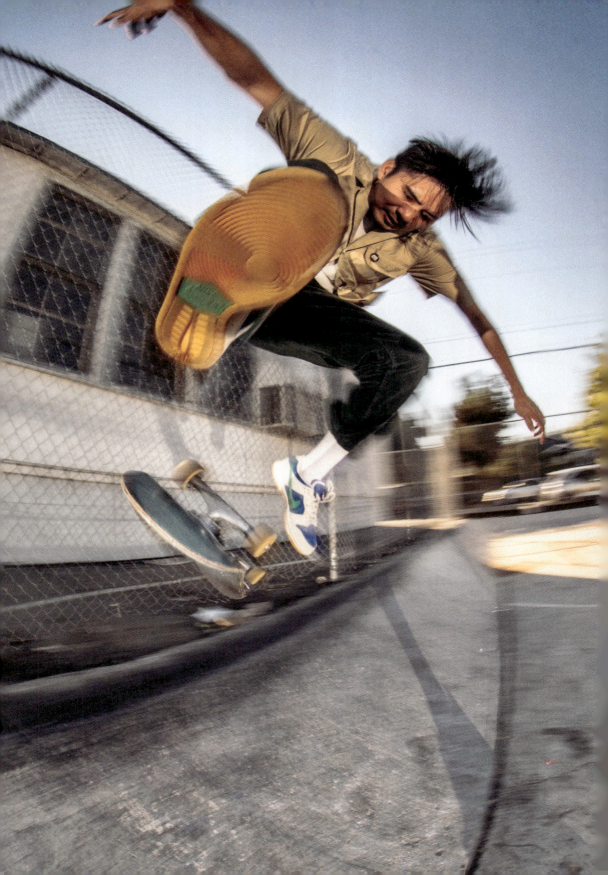

The style of Pat's pieces varies a lot, mainly because he gets bored of doing things the same way. He calls them 'a little kooky at times' but it's all about having fun, which definitely manifests itself in his artwork.

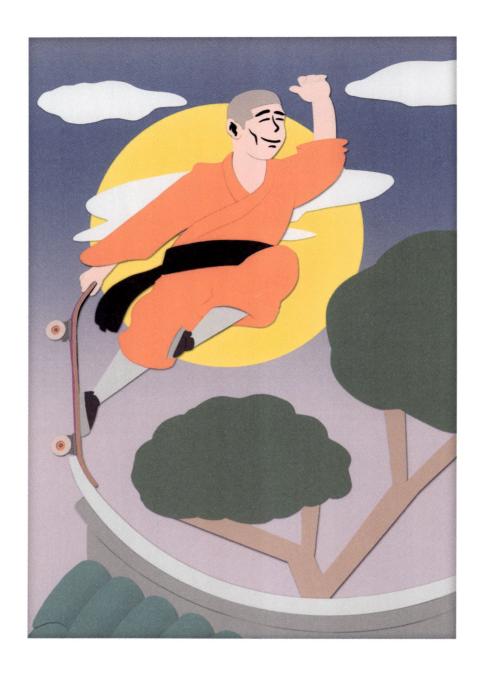

'I saw some Shaolin monks perform some insane balance poses on their staffs much like the illustration and figured, "they can probably do that on a skateboard if it was a thing, but how can I make this gnarlier" and so he's doing a blunt on a roof. This ended up being a nice piece for the homie Al Partanen as he's on his zen mode.'

Shaolin Monkey blunt

'Skateboarding and art seem to go hand in hand.'

Skatehurdles

'NB Numeric was the first one to ever slide into my DMs.'

'This was literally me trying to draw like a Disney animator. Dylan had some lanky-ass legs and I really wanted to accentuate it when I was referencing Atiba's photo of him. Like, he looks like an Eagle hunting a fish out of the water.'

Dylan

Index doubleset

'We'll call this one *Mid 90s* and it's such a dad joke play on the Jonah Hill film. I even threw in the Banksy art shredder reference but used another piece of mine that the older generation of skaters loved so much.'

Q & A
Pat De Vera Sison

Los Angeles, US

You grew up in a Filipino-American household where you were forced into the medical field. You obviously broke this stereotype and pursued a career in the arts despite the expectations of your parents. Are they cool with it now?
My mom was the most opposed, and it's ironic because she's the one who nurtured my love for the arts to begin with. It took a couple of years, but she's really supportive of what I do now.

How did she nurture your love for the arts?
She put me into a preschool/kindergarten that focused on arts, so that set a lot of interest in motion. She would also take me to arts and crafts classes hosted by the local library or church. I was really hooked on making things in general, especially beaded lizard keychains.

So, I assume drawing came before skateboarding?
I was so sure my answer was drawing but, when I take a better look back, I remember playing with my cousin's fish board in my grandpa's living room.

What is your medium of choice?
Paper Mate Flair pens and paper, but the iPad is where I've been finishing everything.

How did you get into skateboarding?
I guess this has to be about skateboarding now *(laughs)*. I've always been captivated by skateboarding, but what really pushed me towards it was seeing my neighbours and cousins getting into it because of Tony Hawk's Pro Skater.

How has skateboarding influenced your work as an artist?
Skateboarding and art seem to go hand in hand. Board graphics from artists like Todd Francis, Fos, Michael Sieben and Don Pendleton have had a huge influence on my work and it's been a struggle trying to stay away from becoming another version of them, although there are elements that I've taken from each of their styles and thought processes.

Which one influenced you the most and in what way?
Michael Sieben and Fos, mainly in terms of how I choose to handle my line art. Fos is also running his own company and still crushing it with collabs. He does so much and still finds time to hit the streets and do what he wants.

Has your work on illustrations also shaped how you skate or how you feel about it?
It helped me view spots from different angles and think of unique ways to skate them. Maybe it's a little kooky at times, but it's fun and that's what it's all about.

You were featured in *Thrasher Magazine*. How did that come about?
Man, the *Thrasher* feature was so random but cool. I was so caught up with creating illustrations that would go viral at the time, in the hope that I could get my foot in the door somewhere. I guess *Thrasher* caught wind of my stuff on Instagram from other people reposting my work and the next thing I knew, I had an email from Michael Sieben.

What has been your proudest moment?
Definitely getting into *Thrasher*. Because it sure as hell wasn't gonna be for my skateboarding.

Have you had any embarrassing or funny moments along the way?
Two moments. I referenced a photo of a scooter kid sucking on his handlebars for an illustration and I got obliterated by the whole scooter community. It was annoying at the time but really hilarious looking back at it.
The second time was when I did a Hook Ups graphic depicting Jeremy Klein in a speedo, glistening in a very provocative pose, and someone sent it to him. He wasn't stoked about it. *(laughs)*

You work for the College Skateboarding Educational Foundation (CSEF), which awards college scholarships to skateboarders. What is your role?
I'm currently the Art Supervisor there, which is just a fancy title. I'm in charge of picking a theme for the season for our recipients, creating the templates related to that season, flyers, collaborations, merch (coming soon), banners, etc. Anything art-related gets run by me. It's a burnout and a half, but it's helping a lot of people and I actually enjoy some of the creative curveballs that are thrown at me.

When did you decide to become a full-time illustrator/designer?
It was when real companies started sliding into my DMs. NB Numeric was the first one to ever slide into my DMs and it was for a project about a Thai skateboarder's colourway that was dropping later that year. It eventually turned into me doing illustration work for Margie's Philippine colourway.

Is there a board company grabbing your attention with their graphics?
I'm a fan of Welcome's older graphics with their edgy linework and popping colours.

What does your dream assignment look like in terms of brand and scope of work?
I'd love to kick it with a specific team to learn about their passions outside of skateboarding and come up with a series of graphics around that.

Last question. If you could interview any person in the world, who would it be?
Sean Wang, the director of *Dìdi*. The film really captured a specific moment of what life was like growing up in the early 2000s that really paralleled my own life. It felt like we had many of the same experiences growing up and it would be awesome to pick his brain. •

21

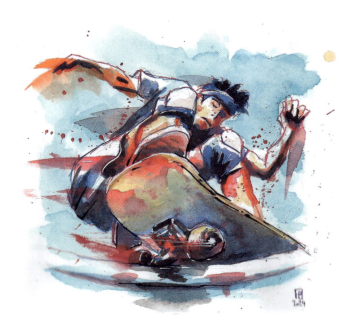

Mountain FS grind

Poetry in motion

Pedro Colmenares Carrero

When Pedro is not working on visual effects for blockbuster movies, he enjoys watercolour sketching as his main creative outlet. You immediately feel the movement, the rush and the energy through his illustrations.

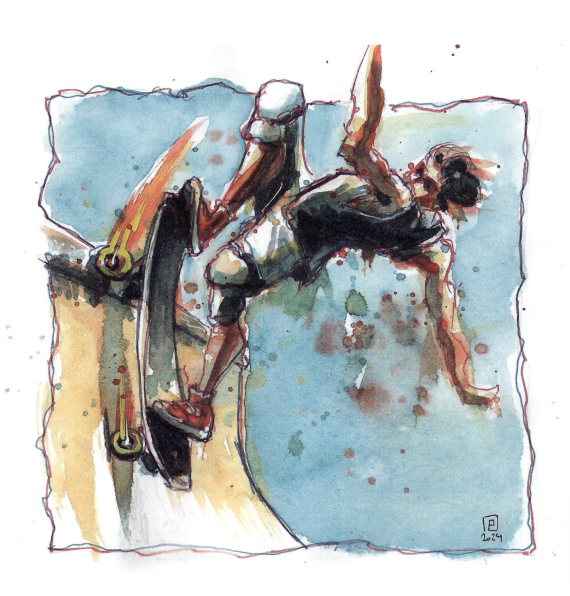

'I was gathering photographs of old school skateboarders using google to search for these references. This one in particular caught my attention because of the extreme rotation of his body, indicating an aggressive Frontside turn on the very ramp.'

Frontside slash

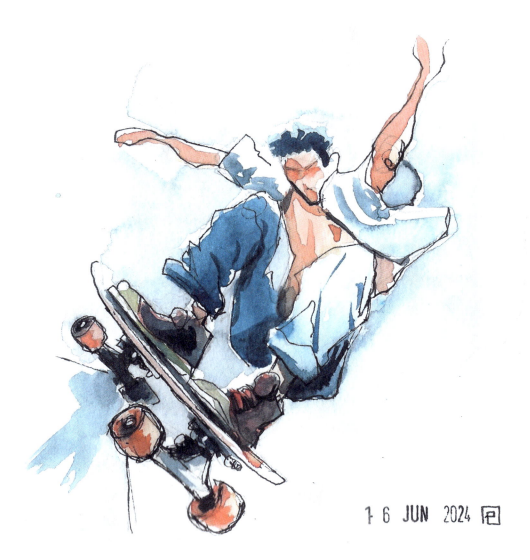

16 JUN 2024

'Once again, this image reference is from Google search. I really liked the camera angle and the outfit of the skateboarder and thought it would make a sick illustration!'

Smith grind

'Skateboarding is pure poetry in motion and it makes a great subject for art.'

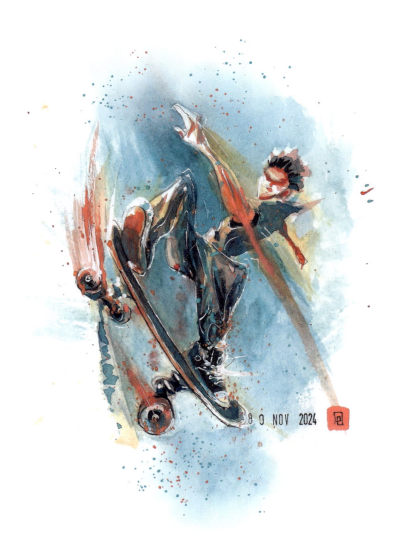

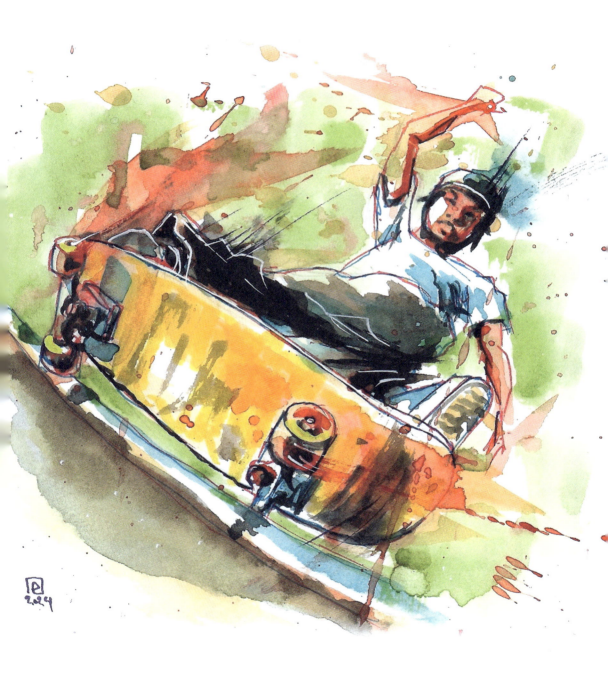

BS slash

Q & A

Pedro Colmenares Carrero

Vancouver, Canada

You do all this digital 2D/3D animation work, which is such a stark contrast to your traditional watercolour paintings. Do you need that balance to stay creative?
I love digital art – it has powerful and efficient tools. However, sometimes these tools can work against the artist. Watercolour forces me to have a plan, to work fast and to accept the mistakes that I make. There's very little room for fixing mistakes and usually it's better not to poke watercolour too much, otherwise it tends to look overworked. At this point in my life, I enjoy watercolour sketching as my main creative outlet. I still appreciate digital art and I'm grateful that my job is about creating digital content, but I definitely enjoy traditional methods at the moment. I also appreciate not having to look at a computer screen. One of the things I enjoy the most is to take my art journals, paint and brushes and do some painting outdoors on a pleasant day.

What came first: drawing or skateboarding?
Skateboarding. A kid in my neighbourhood gave me this skateboarding PlayStation game called Tony Hawk's Pro Skater. That game blew my mind and got me hooked on skateboarding and all its culture.

How has skateboarding influenced your work as an artist?
It has influenced me greatly to be the person I am today, and that gets reflected in my art. I've always said that skateboarding itself is a form of art. And I think it's fair to say that skateboarding and art go hand in hand. Some of the best local skateboarders in my area are also great artists. Some skateboarding legends like Mark Gonzales, Christian Hosoi and Stacy Peralta are also great artists, as well as new generation skateboarders such as Nolan Johnson. They are all very creative people with a great sense of style and a powerful attitude.
When it comes to my art, skateboarding has made me focus on capturing the different ways a human body can move, especially when it comes to air tricks and inverts/handplants, etc. I enjoy paying attention to how the body of a skateboarder in action twists and turns in order to maintain balance during such tricks and I think it always makes beautiful shapes and silhouettes. Skateboarding is pure poetry in motion and it makes a great subject for art.

Have you had any embarrassing or funny moments along the way?
Every artist I know has had to deal with online scammers pretending to be interested in purchasing their art as NFT or whatever. People can sense the malicious intentions of these scammers from the beginning, so this always provides a chance to troll them and have a laugh. I haven't done any commissions yet and I can't think of funny anecdotes at the moment. I've had numerous embarrassing moments during the course of my life, and I'm sure there will be many more.

Are there any other skateboard-inspired artists that influence you?
I really admire the photography work of J. Grant Brittain. He does a wonderful job capturing the exciting action and style of vert and transition skateboarders. Whenever I see any of his photographs, I get this urge to create a watercolour painting version of it. Glen Biltz is an outstanding stop motion animator. He has a solid understanding of the body dynamics in skateboarding and translates it into his animation project. Please check out his work if you haven't already.

What does your dream assignment look like in terms of brand and scope of work?
I think I want to keep my hobbies like watercolour painting and other creative outlets as just that, a hobby. I've experienced burnout in other past passions of mine, precisely because I was trying to pursue goals I had set and that I could not achieve.
Getting so fixated on an idea or a goal sometimes can make me forget about enjoying the process of whatever it is that I'm doing. Being happy and staying focused on the moment is why I choose to keep watercolour painting as a pastime.

Last question. If you could interview any person in the world, who would it be?
Wow, this one caught me off guard, but thinking about it, I can name a few *(laughs)*: Joey Borelli (@joeybtoonz) – I agree with most of all his points of view and his videos and podcasts always make me laugh, Ben Koppl and/or Swampy – I just love their skating style and they both seem very down-to-earth people. Swampy is such a character *(laughs)* – I love him. I have a two-year-old boy, so I'd love to interview him and be able to obtain answers to better understand what he wants and needs. •

22

Robert

Dreamy Lighting

Trevor Humphres

From being a thrill-seeker doing action sports to becoming an artist creating dreamy illustrations, Trevor's philosophy has remained the same: make your hobbies the core of your life.

'I like my work to feel a bit dreamy, with hand-painted textures to make it feel as real as possible.'

'Inspired by capturing the iconic kick motion that every skater does while cruising. I love creating characters that feel like they're in motion, using interesting color palettes and dreamy lighting.'

'I also respect the culture — skateboarding has one of the best sports cultures around.'

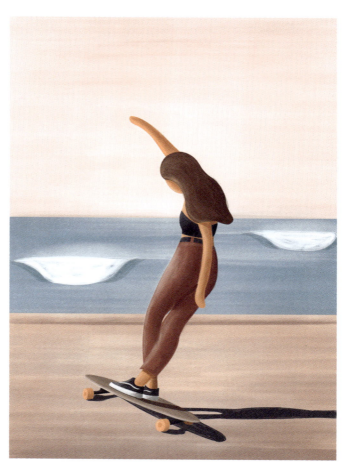

238 Dancing

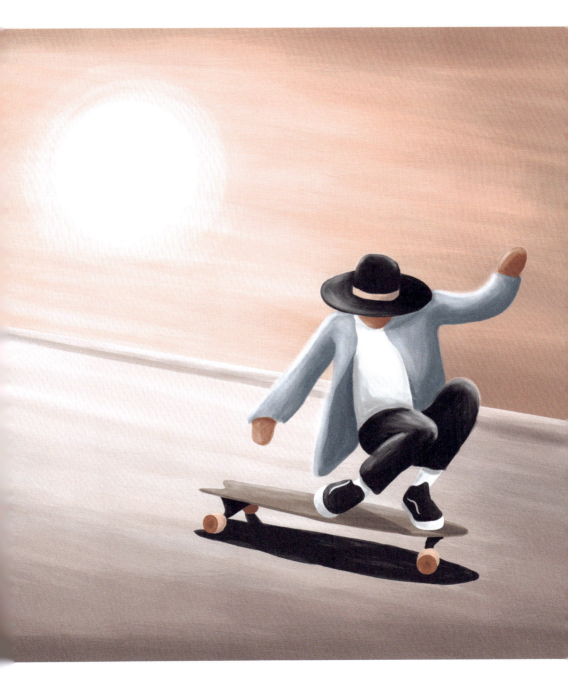

Pure Joy

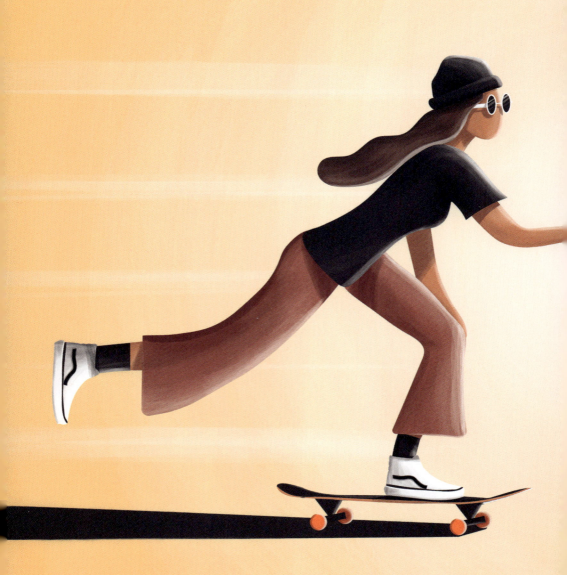

Kick, push, and coast

Hang ten

Q & A

Trevor Humphres

Scheveningen, The Netherlands

You've been a mountain bike downhill racer, snowboard instructor and you moved to Maui to surf. Skateboarding seems to be missing from your list.
Yeah, I've been lucky to do some pretty cool things in my life so far. One thing that's remained constant is the drive to make my hobbies the core of my life. Motion, adrenaline and expression are really important to me, whether it's MTB, snowboarding, surfing or skating. Skateboarding was actually the start of my board sport journey. I grew up in a cabin in the woods in the Black Hills of South Dakota. The only concrete for miles was a slab on my back deck and our garage. That's where I learned to skate. I'd spend hours out there practising kickflips and grinds on my homemade rail. On lucky days, my mom would drive me 40 minutes into town to the skatepark. Those were the best days.

On your website you mention you started drawing when you were injured. Did you put the pen down when you were up and running again?
Yeah, unfortunately, I did. I wish I hadn't because I could've been building my skills at an earlier age. Back then, I thought my purpose and meaning in life were all tied to sports.

How did you get into drawing?
I think it came naturally. My mom was really creative and loved scrapbooking, so she'd take me to the hobby store, and I'd instantly be fascinated by the art tools on the shelves. We lived out in the woods, surrounded by nature – birds, turkeys, elk, deer, mountain lions, squirrels – you name it. I was really into drawing those animals at first. I just used pencils, a blender and paper. That's where it all started for me.

How would you describe your style?
I'd say my style is constantly evolving. Lately, I've been really inspired to create art that brings a feeling of connection and captures moments of pure joy. I like my work to feel a bit dreamy, with hand-painted textures to make it feel as real as possible.

What is your medium of choice?
I really like working in Adobe Illustrator. All the work you see here was created in that program. I love the clean lines and crispness Illustrator brings. But I also work in Photoshop, and lately, I've been really into drawing in my sketchbook with Micron pens.

You include skateboarding in some of your illustrations. Is there a special connection?
Absolutely. I'll always have a special respect for skateboarders. The amount of drive and resilience to failure is immense. Out of all

the sports I do, skateboarding will forever be the most difficult. I also respect the culture – skateboarding has one of the best sports cultures around. As an avid surfer, I sometimes cringe at what happens in and out of the water, but my experience with skateboarding has always been about dedication, respect and staying real to the craft. Some of my best memories are on a skateboard, whether it's learning kickflips non-stop in my garage, longboarding down hills in college, or skating the mini ramp with friends.

Have you had any embarrassing or funny moments?
Gosh, where to even start! This is so important for any aspiring artist or illustrator – embarrassing moments, failures, doing things wrong, it's all part of the process. I've got off so many phone or video calls with clients thinking, 'Wow, I really don't know what I'm doing.' I even gambled an entire year of my time and work on an NFT project that didn't pay off and caused a burnout for another year. But the key thing to remember is to keep going and not quit – things will work out.

You started full-time freelancing in 2020 when the pandemic hit. Did a special moment lead to that decision?
At that time, I knew I needed to bring my creativity to life. I had stuffed it away for so long, and it became clear I needed an outlet. Luckily enough, I lost my job due to the pandemic and suddenly had plenty of free time. Before that, I was a leader for a company called Backroads, where I took people on cycling holidays around the world. One of my tasks was creating a welcome document for new leaders coming into the area, and I found myself adding fun designs and drawings to it. My girlfriend, who's a web designer, suggested I try Illustrator if I enjoyed it so much. She let me use her old computer, and from that point on, I spent every day learning and drawing.

Any advice for people that want to be a full-time artist as well?
My advice would be to not be too hard on yourself. We tend to want everything to be perfect. Show the world what you're working on – all of it, not just the completed pieces. It's important to realise you don't need to have it all figured out before you dive in. Otherwise, it can feel too daunting. Let opportunities come, and let your journey flow. There are so many different ways to make a living from art.

There are so many online platforms for artists to share and promote their work. Which one do you like best?
I really like Instagram and X. I've had some great opportunities come from both. I think the key is to show your work, no matter the platform, and remind people often that you're still here, honing your craft.

What does your dream assignment look like in terms of brand and scope?
My dream project would be creating custom skate decks or website illustrations for a cool skate brand. I'm not going to drop any names, because it doesn't have to be the biggest company – just a cool project with cool people where I can align my passions and also get paid.

Last question. If you could interview any person in the world, who would it be?
It would be my mom. She was taken way too early, and I'd give anything to sit and chat with her, even for just an hour. •

23

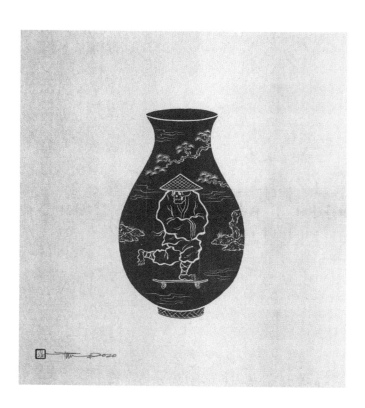

Vase

Ancient tranquillity

Tuck Wai

Looking at Tuck's illustrations, you could easily mistake them for Chinese paintings dating back a few thousand years. Living in Singapore, his daily exposure to Eastern and Western cultures features prominently in his illustrations.

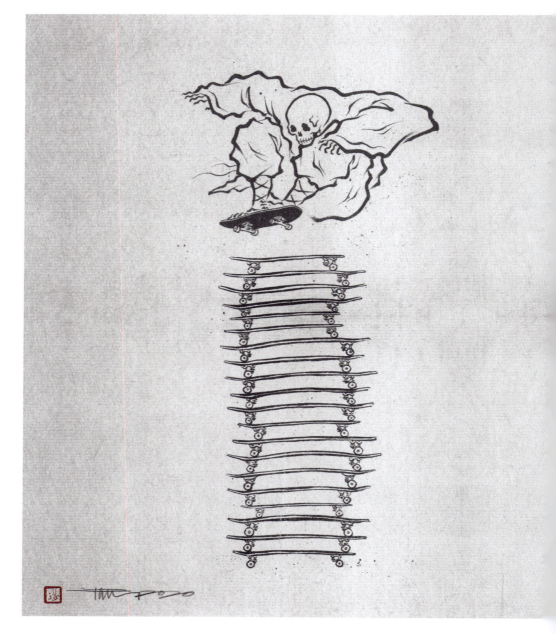

Ollie

n captivated
 the
nquillity
Chinese
d Japanese
intings.'

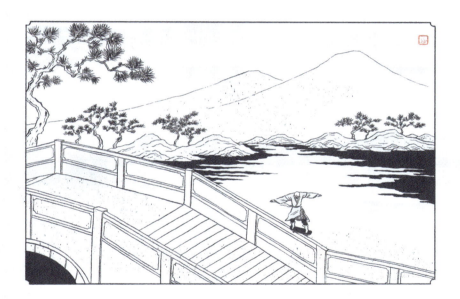

'This piece was inspired by Japanese Ukiyo-e prints and Chinese paintings. I decided to add contrast to the peaceful setting and have some unexpected elements in the environment. Therefore I added a skateboarder doing a 5-0 grind down the bridge.'

Bridge

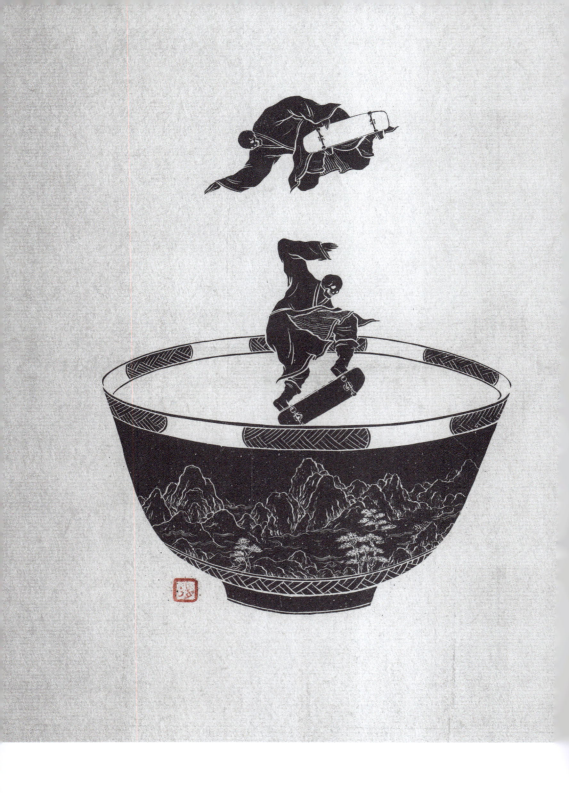

Bowl

'There's so much creativity and mind-blowing work coming from artists in the skateboarding community.'

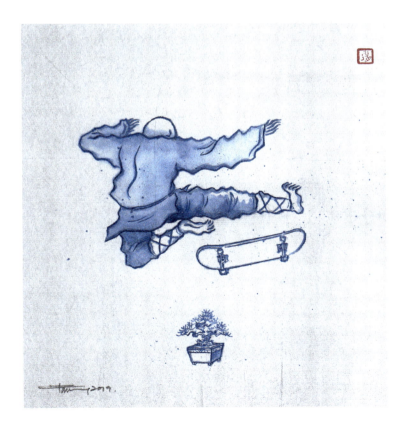

Kickflip

Q & A

Tuck Wai

Singapore

What is it like being an artist in Singapore?
I feel incredibly fortunate and grateful to be pursuing art in Singapore. Growing up in this multi-racial country, the melting pot of Eastern and Western cultures often influences my illustrations. The art community here is small, with people being generally friendly and supportive of one another.

What came first: skateboarding or drawing?
Drawing was definitely my first passion, and I believe I inherited it from my mum. She's not a professional artist, but I remember being captivated by her drawings and Chinese handwriting when I was a kid. Comics and cartoons further sparked my imagination and fuelled my desire to draw.

Were there any comics or cartoons in particular that grabbed your attention?
As a kid, Garfield was one of my favourites. During my teenage years, my older brother introduced me to *Ghost Rider* and we covered our bedroom wall with *Ghost Rider* posters, which drove our mum crazy! I was also obsessed with classic American cartoons like *Masters of the Universe*, *M.A.S.K.*, *Transformers* and *Teenage Mutant Ninja Turtles*. Those were great times spent sitting in front of the TV watching cartoons!

How did you get involved with your other passion, skateboarding?
My brother introduced me to skateboarding when he got a California Pro board from a local sports shop. He was the gnarly one in the family, and I always followed his lead when we were young. With both of our parents working hard to make ends meet, we were latchkey kids, heading out to skate unsupervised after school almost every day. That routine lasted for four years until 1992, and those were some of the best times of my childhood. I started skateboarding again in 2009 and made many new friends. I'm not great at it but I'm thankful I still get to skate in my 40s.

What is your medium of choice?
I enjoy painting with sumi ink on rice paper. Traditionally, Chinese calligraphers and painters use Chinese ink on rice paper. I've experimented with different inks and now prefer a specific Japanese brand of sumi ink for its rich, jet-black colour. My process differs from traditional Chinese painting techniques, where pencil drafts are typically not used before applying ink.

Your skateboard illustrations look like ancient Chinese paintings. What is it that fascinates you about these?
I'm captivated by the tranquillity in Chinese and Japanese paintings; it relaxes me, and I strive to convey that same calm through my brushstrokes.

How has skateboarding influenced your work as an artist?
Skateboarding has profoundly shaped my creative journey, impacting my artistic identity and directing my illustration style. It keeps me connected to a youthful mindset, which is essential for making art. There's so much creativity and mind-blowing work coming from artists in the skateboarding community, and I aspire to be a part of it.

What has been your proudest moment?
When Real Skateboards commissioned me to design skate graphics for Ishod Wair and Dennis Busenitz in 2016, it felt like magic. Creating pro model graphics for these world-class skateboarders was truly humbling. I'm also grateful for the opportunity to create several more designs for pro skateboarder Kyle Walker, who was really kind to send me a thank you message on Instagram.

At what point did you decide to go all in as a freelance artist?
The design company I was working for wasn't doing well, and I found myself at a turning point. Seeing the positive feedback on my Instagram drawings made me realise perhaps it was time to take a chance. After discussing it with a few trusted friends who asked, 'If not now, then when?' I decided to go for it. Transitioning to self-employment after 15 years of working for someone else was definitely a daunting step. I experienced moments of self-doubt and imposter syndrome that I had to conquer, but I'm committed to making a living through my art and illustrations.

What does your dream assignment look like in terms of brand and scope of work?
Music and the 90s MTV era are major inspirations for me, so creating larger-than-life projections for music festivals feels like a dream assignment. I often daydream about seeing my characters come to life through animation as backdrops for music events or even in a music video. It would also be incredible to illustrate album art or gig posters for rock bands like White Zombie.

Are there any other skateboard-inspired artists who influence you?
I'm deeply inspired by Usugrow's art – his impeccable brush control and intricate stroke details are truly remarkable. Jef Hartsel's work also captivates me with its unique style and flow. His art often expresses profound wisdom and a deep appreciation for living in the moment, something I can learn a lot from.

Last question. If you could interview any person in the world, who would it be?
I'd love to chat with Wayne White. I've watched his documentary *Beauty Is Embarrassing* countless times, and I'm convinced there's still so much to learn from him. I think he'd provide entertaining and creative insights on thriving in the art and illustration world, all while keeping the conversation light and humorous. •